WONDER

THE ART AND PRACTICE OF BEATRICE BLUE

Website: www.3dtotal.com

Correspondence: publishing@3dtotal.com

Wonder: The Art and Practice of Beatrice Blue © 2019 3dtotal Publishing.

Every effort has been made to ensure the credits and contact information listed are present and correct. In the case of any errors that have occurred, the publisher respectfully directs readers to www.3dtotalpublishing.com for any updated information and/or corrections.

First published in the United Kingdom, 2019, by 3dtotal Publishing.

Address: 3dtotal.com Ltd, 29 Foregate Street, Worcester,
WR1 1DS, United Kingdom.

Reprinted in 2020 by 3dtotal Publishing

Soft cover ISBN: 978-0-9551530-9-9
Printing and binding: Everbest Printing (China)
www.everbest.com

Visit www.3dtotalpublishing.com for a complete
list of available book titles.

Managing Director: Tom Greenway
Studio Manager: Simon Morse
Assistant Manager: Melanie Robinson
Lead Designer: Imogen Williams
Publishing Manager: Jenny Fox-Proverbs
Editor: Sophie Symes

FSC
www.fsc.org

MIX
Paper from
responsible sources
FSC® C124385

ONE TREE PLANTED FOR EVERY BOOK SOLD

OUR PLEDGE

From 2020, 3dtotal Publishing has pledged to plant one tree for every book sold by partnering with and donating the appropriate amounts to re-foresting charities. This is one of the first steps in our ambition to become a carbon neutral company with carbon neutral publications, giving our customers the knowledge that by buying from 3dtotal Publishing, we are working together to balance the environmental damage caused by the publishing, shipping, and retail industries.

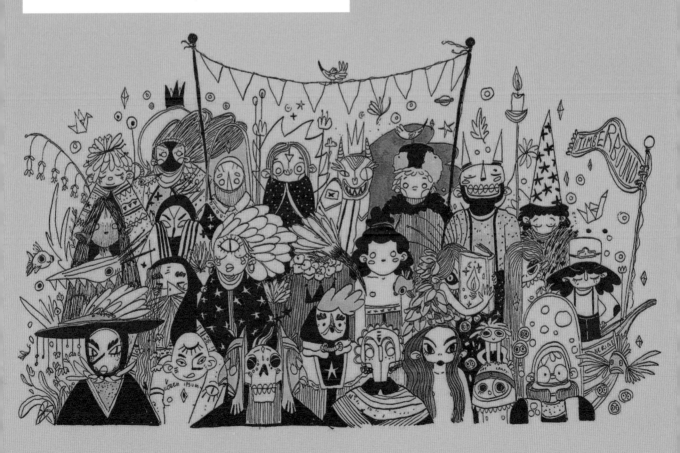

CONTENTS

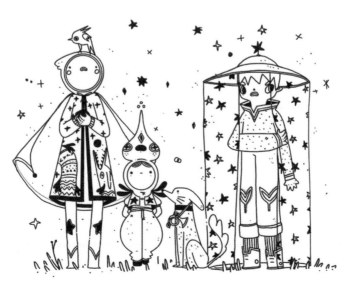

FOREWORD

DANI DIEZ

We all like to think there's something more to what we see. We want to think that's true and that magic is, somehow, possible.

For the last four years, I've been sharing my life with Bea. We've been growing, traveling, drawing, and working (sometimes too much, you know...). We've been discovering the world and evolving; and all of this we've been doing together. Imagine an old tree, as old as time, and now picture yourself in front of it. That tree has always been in your garden and even though you've always liked it, you've never realized that there was a blue wooden door on it. The door was hidden by ivy and tall grass but yes, deep down you know that the ivy or the grass weren't actually hiding it. The door was hidden because you've only ever seen a tree.

Now you look around and you discover more doors. Small doors that lead to paved alleys, a tiny one on one side of your grandpa's toolbox, and some others with ornamented locks that you'll figure out how to open later...

Bea once told me that all reality depends on the eye of the observer, on how much or how little they want to see. When I first met her, she gave me a glass marble and made me look through it. All around me looked distorted and wavy and I discovered that buildings were not straight anymore, cars seemed to be sailing on the roads, and people walked in strange ways. Of course, I was looking through a marble that was distorting the image, but I was also realizing that there are a million hidden things out there and a million ways to see and discover them. Embracing that world and embracing imagination has been our way of life since then, and that world that was once hidden and small is now as important as the other side. We took a part of us and made it live there permanently.

You're about to open that blue door now, but right before you push it, please look closely. There's a carved inscription on it; it was impossible to read moments ago but now you can see it clearly...

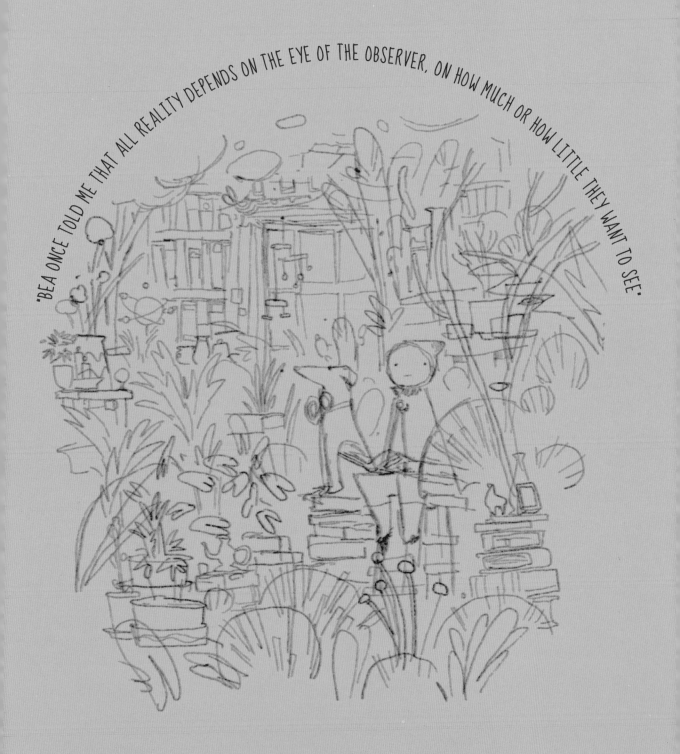

"BEA ONCE TOLD ME THAT ALL REALITY DEPENDS ON THE EYE OF THE OBSERVER, ON HOW MUCH OR HOW LITTLE THEY WANT TO SEE"

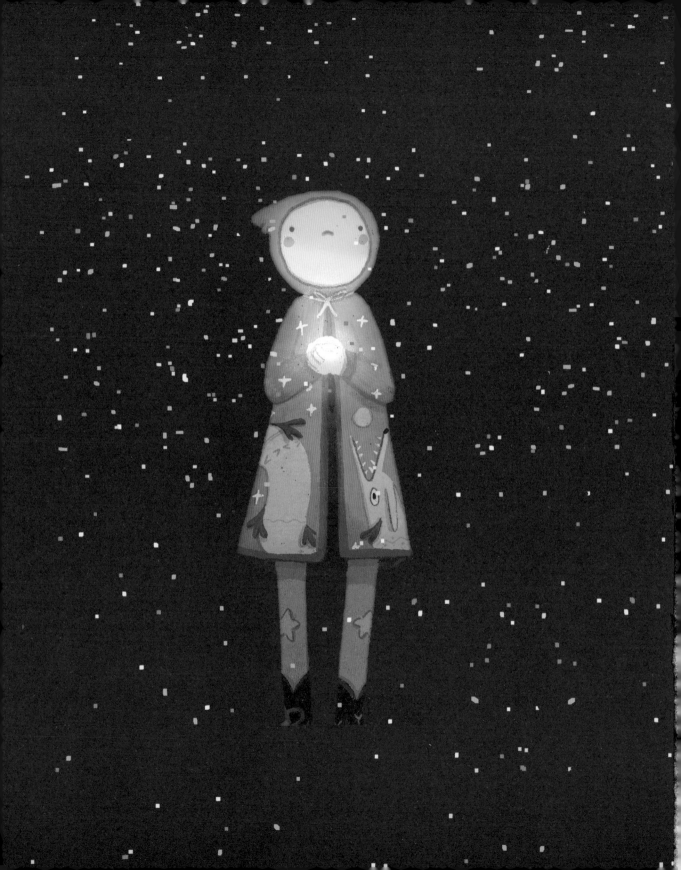

WONDER

The way we view the world is somehow unique to each one of us.
We can see a tree for example as a living being, as a castle of adventures, or
as an inspiration for a painting, among many other ways.

It's all about our approach to each subject, object, or matter. It is about us.
A mindset.

I've always enjoyed being very cautious about the way I view what surrounds me,
especially after reading books such as *Peter Pan*. I believe everything can be as good
or as bad as you want it to be. Or as simple, or as magical.

Everything I see is not only something that just happens to be there, but a
consequence of feelings and opinions.

This has always been a very curious subject to me.
The way I usually like to view things, feelings, and choices is as Treasures.

Treasures are not necessarily good. Treasures are the things I've chosen, decisions I've made
along the way, things I've seen, or objects that carry a story or a certain memory or feeling.

At some point when I was younger, I remember being afraid of losing all these little
Treasures. Some are objects that you can carry, but what about the Treasures that
you cannot see or carry?

I remember thinking of all the Treasures I could discover in just a day, and that maybe
I should write them all down to make them physical and to be able to remember them
whenever I acquired more.

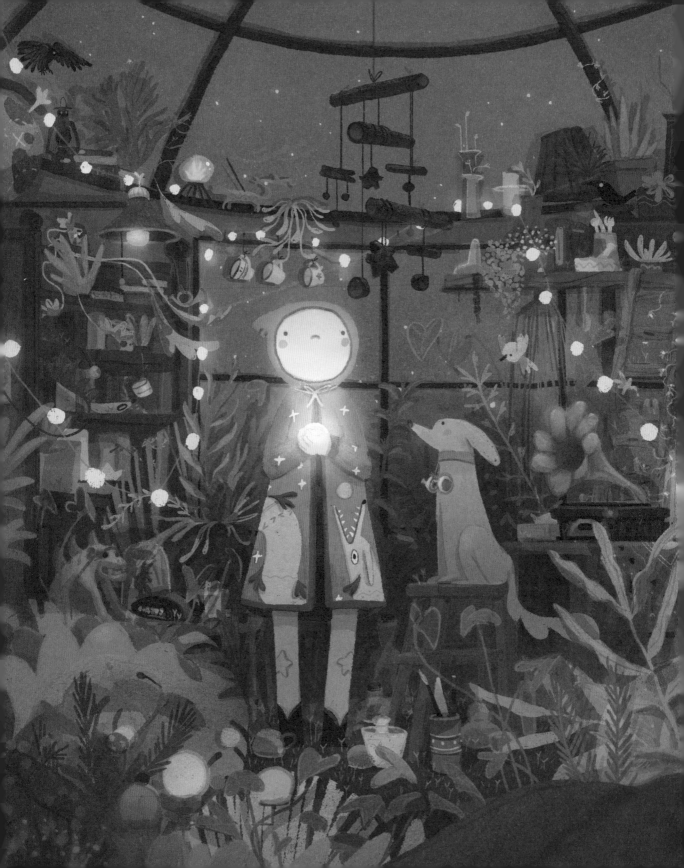

Then I realized all those Treasures never disappear. For they all hide in a certain spot.

In my mind there is a room. It has high glass ceilings and walls, it's always nighttime, and the night sky is always visible.

In this room there are all types of plants. Some of them come from expeditions to the forests, others are a compilation of shapes I like or a scent that reminds me of a certain park or a particular place. There are also random objects, including the wood, cinnamon, and orange mobile that my dad made for me a few winters ago. Also, a thousand and more stories; you can find one hidden in the green transparent marble my grandad gave to me when I was three. Or another one inside the mirror I used to look inside for answers.

You see, this room is not only compounded by objects; it's made of experiences and thoughts locked in objects or colors in a room so they never escape. My room always looks different, because it expands with each acquired Treasure. And everything fits. Everything will always fit.

These Treasures are therefore no longer Treasures alone, as they become something bigger the moment they enter the room. They become Wonders. Because they become me, and I become them.

Beatrice Blue

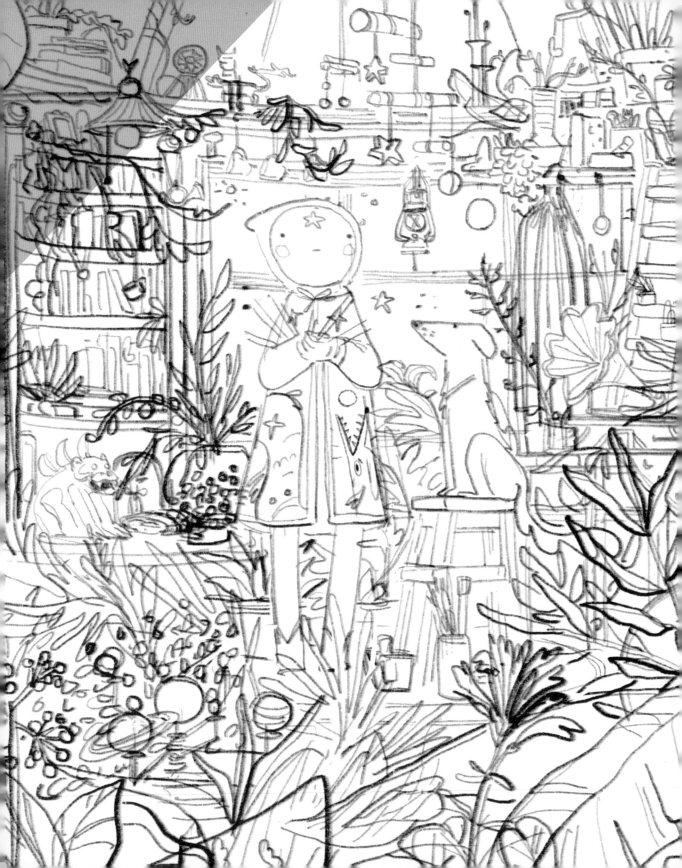

THE EMPTY GLASShOUSE

Imagine a glasshouse. Empty inside. So big, so tall it echoes with the slightest of steps. You can see the stars from every angle through the gigantic dome ceiling.

It is yours; nobody will ever come inside. There are no sounds yet but the ones you will make. No objects but the ones you will bring in, and no memories but the ones you will leave here. It will take years to make it look exactly as you want and to figure out what's the best possible way to make it as beautiful as it can be.

Look around your glasshouse for a moment. Take a walk and hear your echo. This room will never be as empty as it is right now. It's full of possibilities and future Treasures. Don't fear it; embrace it, love it and remember it, because it will never look like this again.

CREATIVE BEGINNINGS

I've been drawing and painting ever since I can remember. My parents have always encouraged my sister and I to be creative. As children we would to make music, paint, and build things together.

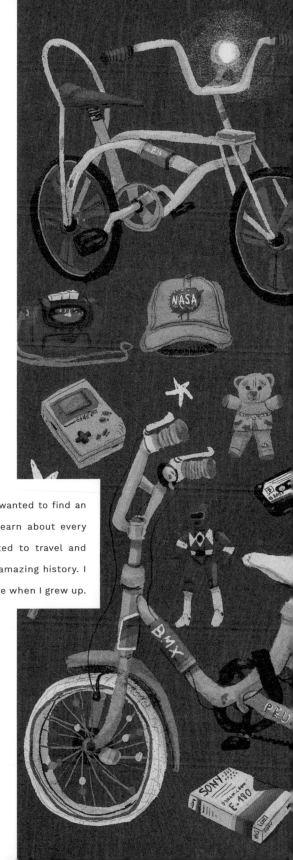

As well as the arts, I was fascinated by science and wanted to find an answer to everything in the universe. I wanted to learn about every species of animal, plant, and type of rock. I wanted to travel and discover different cultures and languages and their amazing history. I found it extremely hard to choose what I wanted to be when I grew up.

"I WAS FASCINATED BY SCIENCE AND WANTED TO FIND AN ANSWER TO EVERYTHING IN THE UNIVERSE."

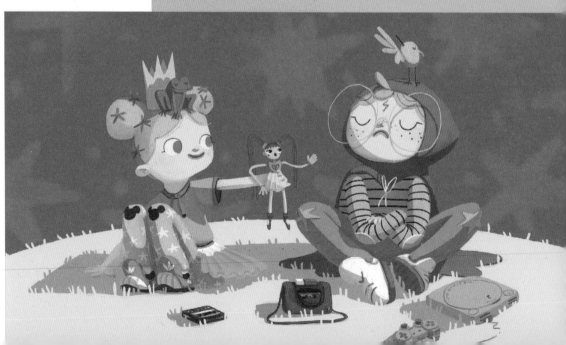

As I grew older, I enjoyed reading and often lost myself in fairy tales, poetry, and science fiction. Video games and films also provided me with a rich source of inspiration. I would escape into captivating games such as *The Legend of Zelda*, and the mesmerizing worlds of adventure movies, while waiting for my letter from Hogwarts to arrive.

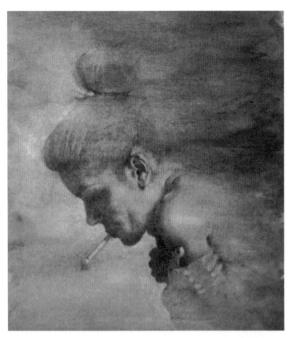

EDUCATION

I ended up enrolling in an animation school in Madrid. During that period, I was lucky enough to meet Amaya Gúrpide – my figure drawing teacher and friend – and her husband Jordan Sokol, who encouraged me to go to New York to learn more about anatomy and classical painting. I fell in love with it all; especially figure drawing and oil painting.

I used to spend several hours a day drawing and painting from life, as well as from models. My tool kit was reduced to just a pencil and a few oils.

While studying at the National Academy of Arts and the Art Students League in New York City, I was fortunate to have the chance to learn from Eric March, Dan Thompson, Michael Grimaldi, Gabriela Dellosso, and Dan Gheno, among many other amazing artists.

I received a scholarship which allowed me to continue studying there, but when the scholarship came to an end, I returned to my home country, Spain.

PERPETUAL MOVEMENT

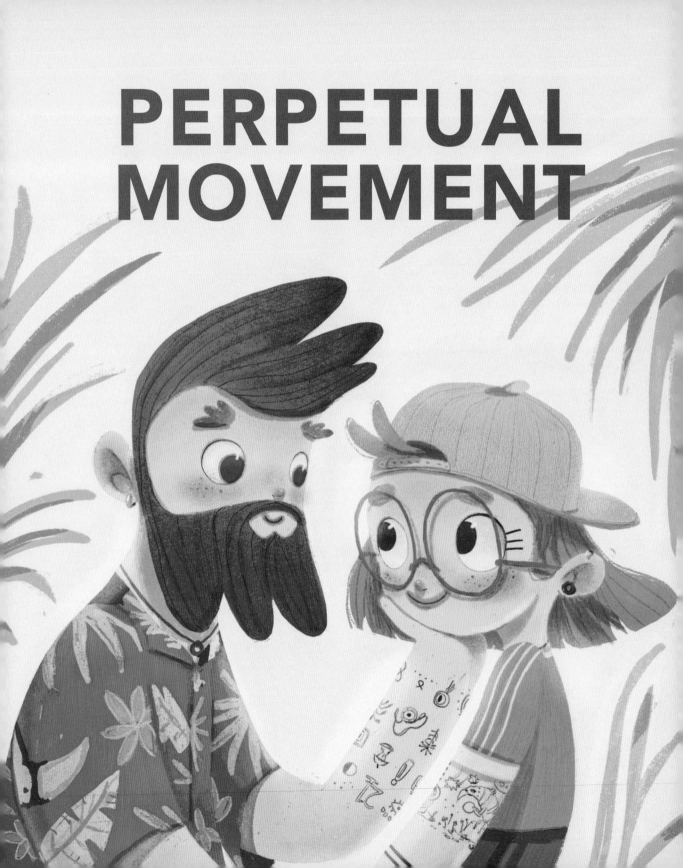

I decided that I wanted to travel and discover stories to tell, so I began working and traveling with my life in a backpack. I lived in different places across the world before meeting Dani during a week-long visit home to Madrid before embarking on my next adventure. After my trip I returned to Madrid and stayed with him.

We exchanged a guitar class for a digital painting class, (although he already knew how to play guitar and was just trying to be humble). Digital painting was very hard. Especially coming from long hours with oil paints and mixing my own colors. But I kept learning. The possibilities felt endless. It felt like something huge to learn — a black hole into my future, and my time.

At first, I wasn't sure if it was going to be beneficial at all, because everything I did looked so bad.

"I DON'T EVER WANT TO STOP LEARNING"

I learned that each drawing I create and mistake I make helps me to grow, tell better stories, and become the artist I want to be.

I want to create and share magical stories. Stories about the universe. About animals, plants, and rocks. About languages, cultures, magic, and mythical beasts. And everything else in-between. I want to be able to tell all the lives I cannot live, simultaneously, and the fifty hours a day I will never have.

I don't ever want to stop learning, discovering, and sharing.

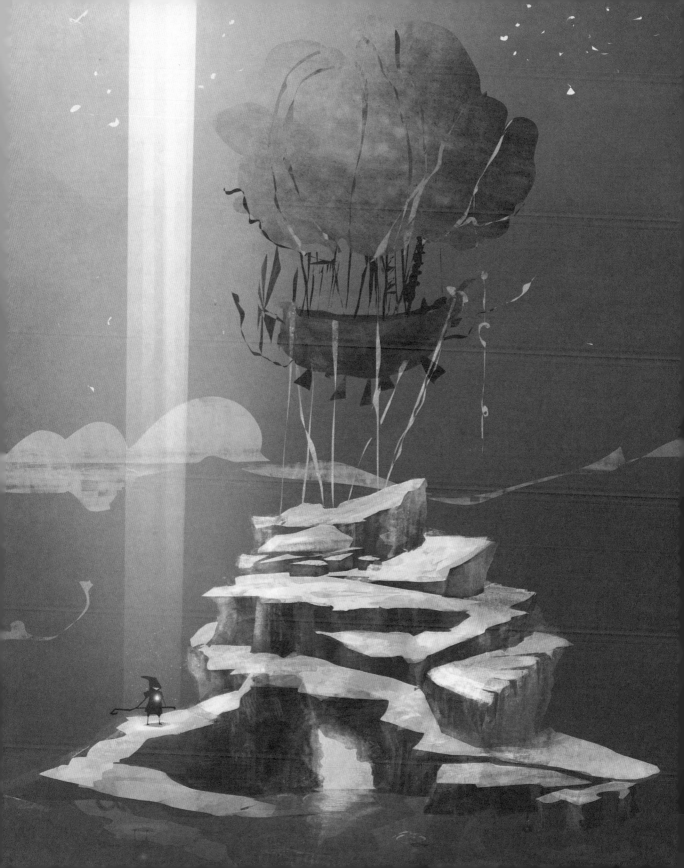

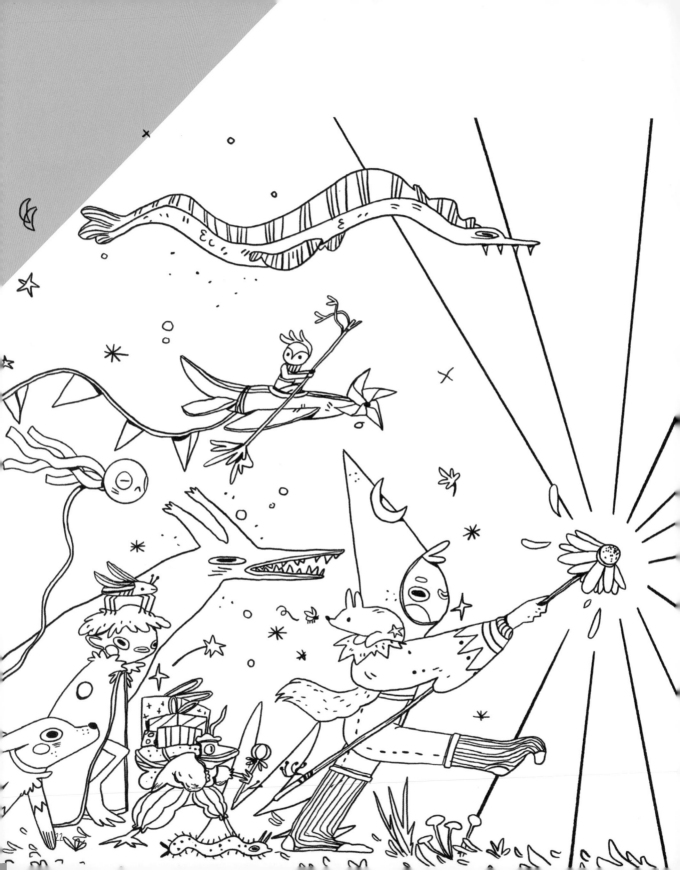

FINDING TREASURES

Back to our empty glasshouse. As I said before, we can leave anything we want in here. It can be memories, sounds, objects, decisions, or questions. Anything at all. But how do we start? What I would do is search for what I like and dislike – starting with the simplest things.

If I feel like I want to go for a long walk in the forest, or read under a tree, I try my best to go and do it. It can be anything that fulfills you – however big or small that may be.

The aim is to come back to your glasshouse with a collection of experiences to use in future creative ventures.

SEARCHING FOR INSPIRATION

I find visiting different cultures and countries incredibly fulfilling, and all of those interesting places now bring me great memories. Every place I've lived is unusual in some way and quite different from all others. But one of the most beautiful things I've experienced while traveling is the people I've met along the way.

I revel in the signs of life all around – the intricate wonders of museums, little lost villages, old bookstores and libraries, busy markets, and bustling cities, and I adore visiting the studios and workshops of other artists.

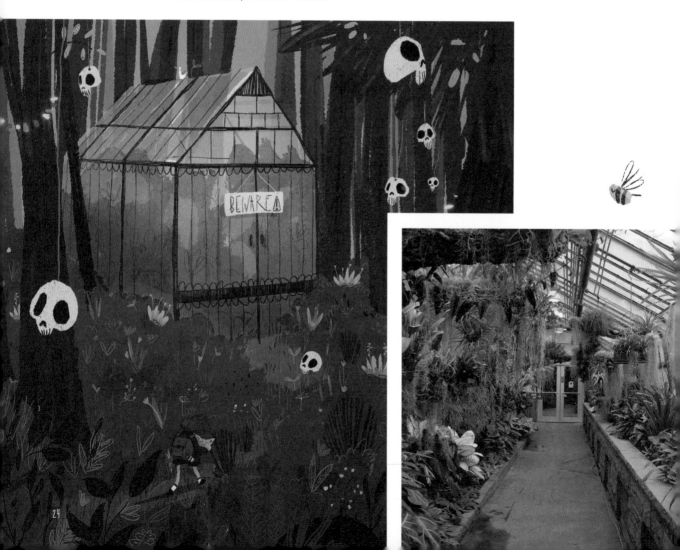

Living in different places around the world has definitely shaped the way I create, and enhanced my creative abilities. The world is full of wonders — stories to tell, colors to enjoy, and lots of history, shapes, and magic. When I travel, I try to absorb as much as I can. Then my aim is to transform those experiences into new stories for everyone who'd love to see or hear them. And in that process of discovery, I shape myself as well.

Venturing into the unknown to find Treasures is one of the huge passions and inspirations behind everything I do. My heart belongs in the forest and the mountains. If I hear that there is a forest nearby, I have to explore it. I deeply enjoy hiking up mountains and bouldering.

I also love visiting as many greenhouses as I can find. I enjoy spending time in all natural spaces, including lakes, rivers, natural pools, waterfalls, and botanical gardens, as well as less conventionally beautiful places such as agricultural fields, factories, abandoned buildings, and foreign supermarkets.

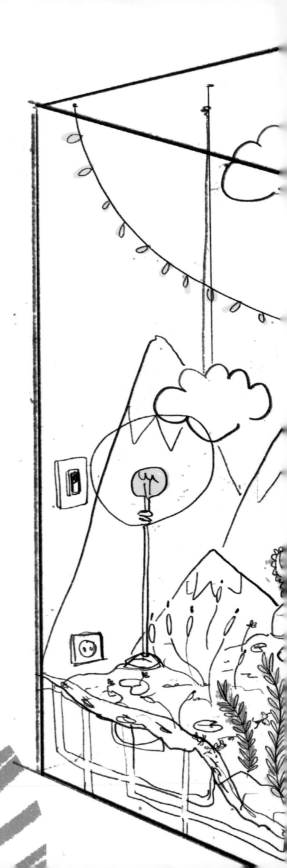

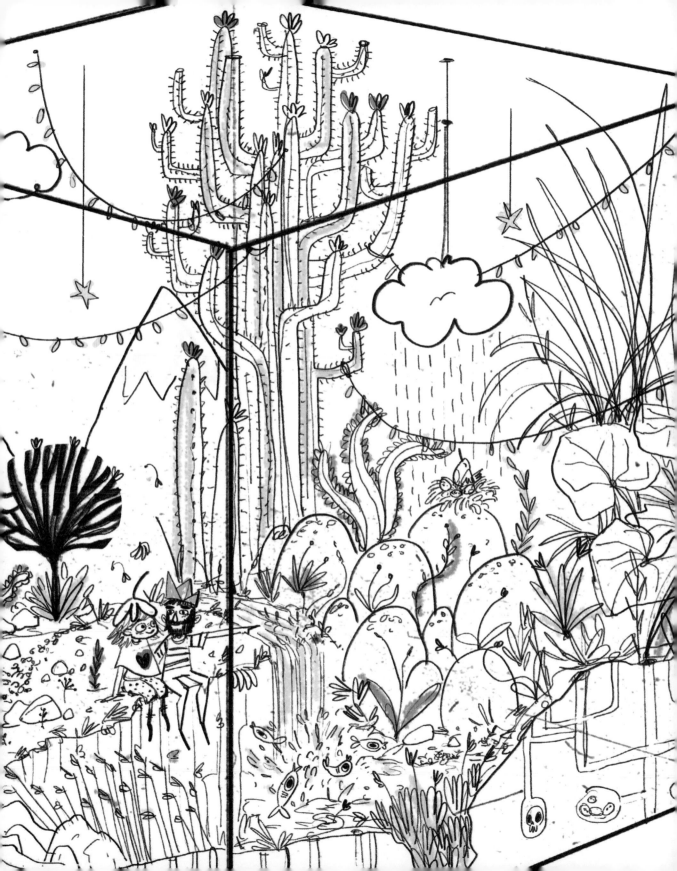

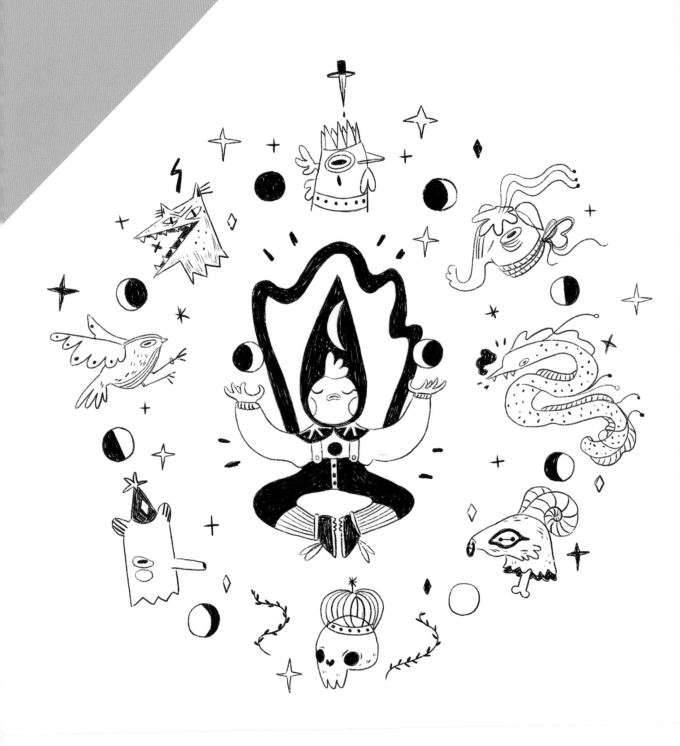

THE TREASURES

Now that we're back in our empty glasshouse with all these experiences accumulated, what can we do with them? We can do several things: go search for more, toss some away if we don't like them, or keep some in the glasshouse for ourselves.

Let's say I pick a memory or a thought I collected. Or an object, or a sound. The moment I decide to bring any of these into my glasshouse, it becomes a Treasure.

Treasures are not necessarily good or bad. Treasures are the choices that define me and make my glasshouse unique, and in time, a huge Treasure in itself.

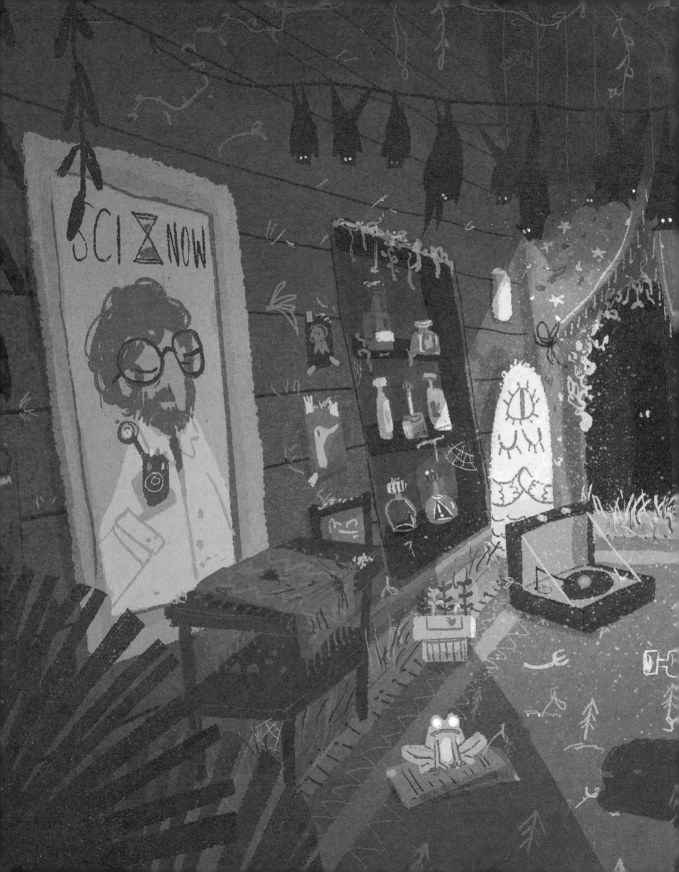

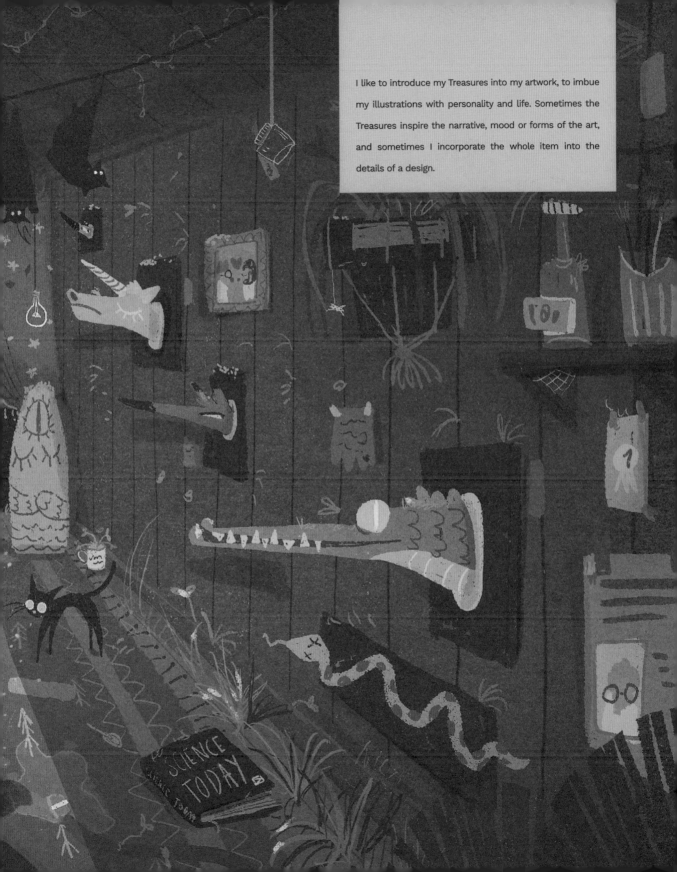

I like to introduce my Treasures into my artwork, to imbue my illustrations with personality and life. Sometimes the Treasures inspire the narrative, mood or forms of the art, and sometimes I incorporate the whole item into the details of a design.

PRECIOUS DETAILS

I believe that details can become as important as a character, or just used as a purely decorative accent. But I always try to put a bit of myself into each one.

This practice originated from when I worked on my first feature film. While working in the art department, my colleagues and I would put little hidden details in the movie props, costumes, and names.

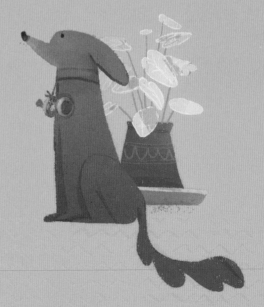

We would add funny messages and details for our loved ones or friends, so that they could be discovered when the movie was released and watched. It felt like creating a precious gift to someone. I take joy from adding little details that can make someone smile. It's one of the ways I like to say thank you, or to remind people I love how much they mean to me.

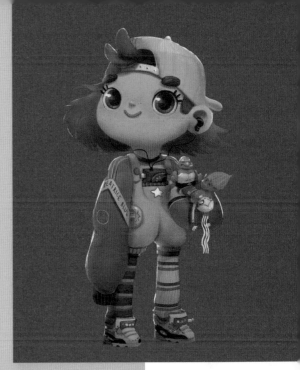

The elements I add depend on the story that needs to be told.

My tendency is to overwhelm a design with details and embellishment, but when I have a specific story or message I want to convey, I have to force myself to keep it simple.

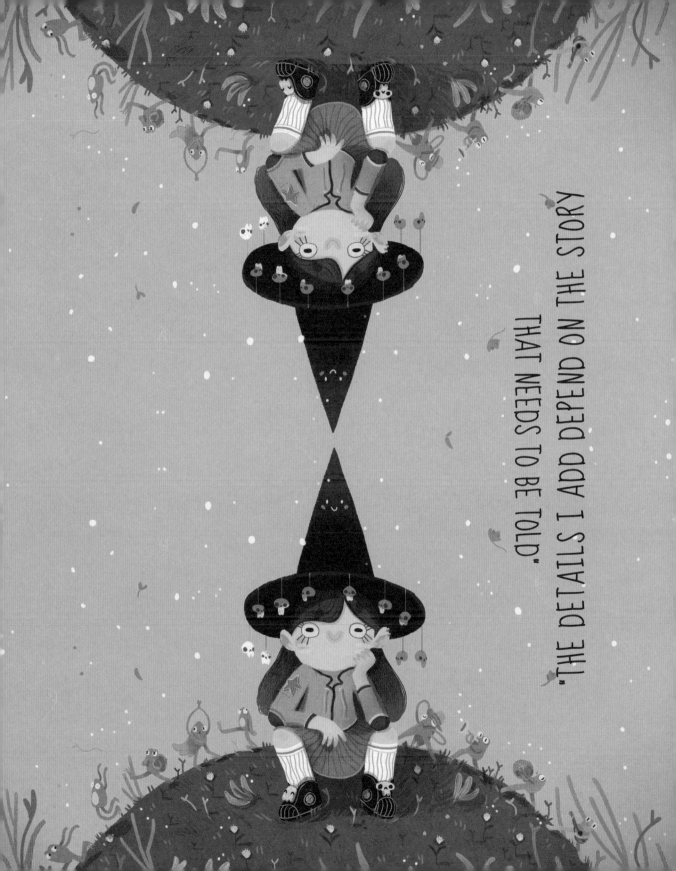

"THE DETAILS I ADD DEPEND ON THE STORY THAT NEEDS TO BE TOLD."

DISCOVERING YOUR TREASURES

Treasures are not always physical objects. They can be a precious memory, a thought, a scent, or a sound, among so many other possibilities. They can be whatever makes you feel good and whatever you believe defines you.

Try a slower pace of life and take time to absorb your surroundings at every opportunity – you may see things you hadn't noticed before!

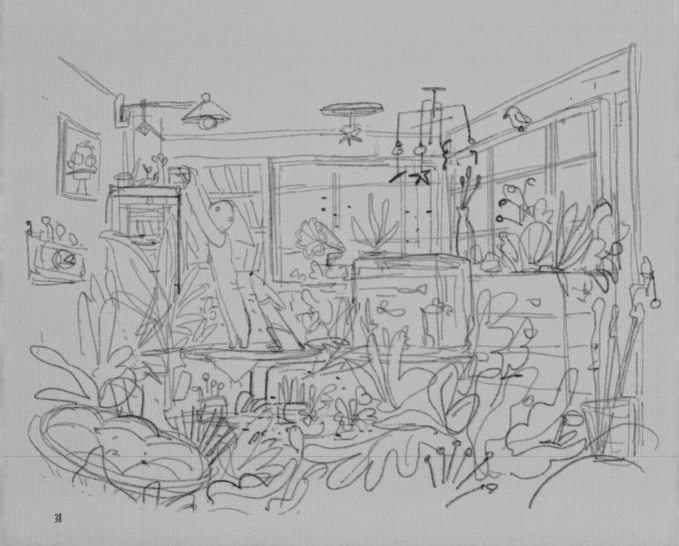

"TREASURES ARE NOT ALWAYS PHYSICAL OBJECTS. THEY CAN BE
A PRECIOUS MEMORY, A THOUGHT, A SCENT, OR A SOUND"

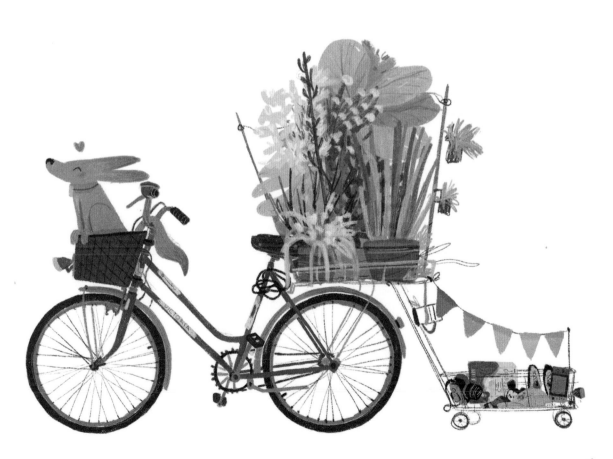

Since I was a little kid, I've always dreamed of having a
doggy. So, as part of my Childhood Week social media
challenge, I drew my inner child loving one of my biggest
treasures, Jungle. I loved her before she was even in
the world.

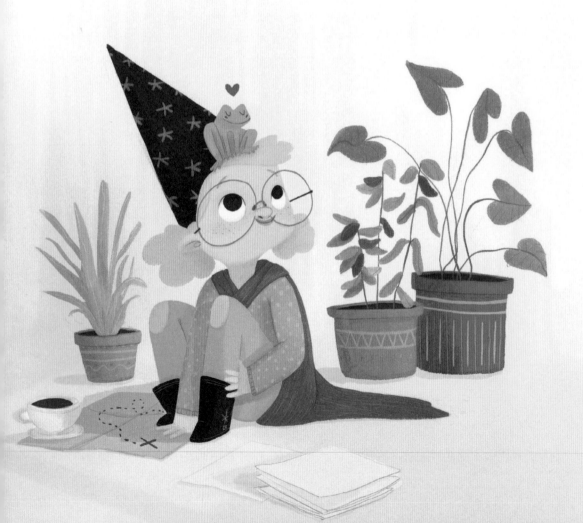

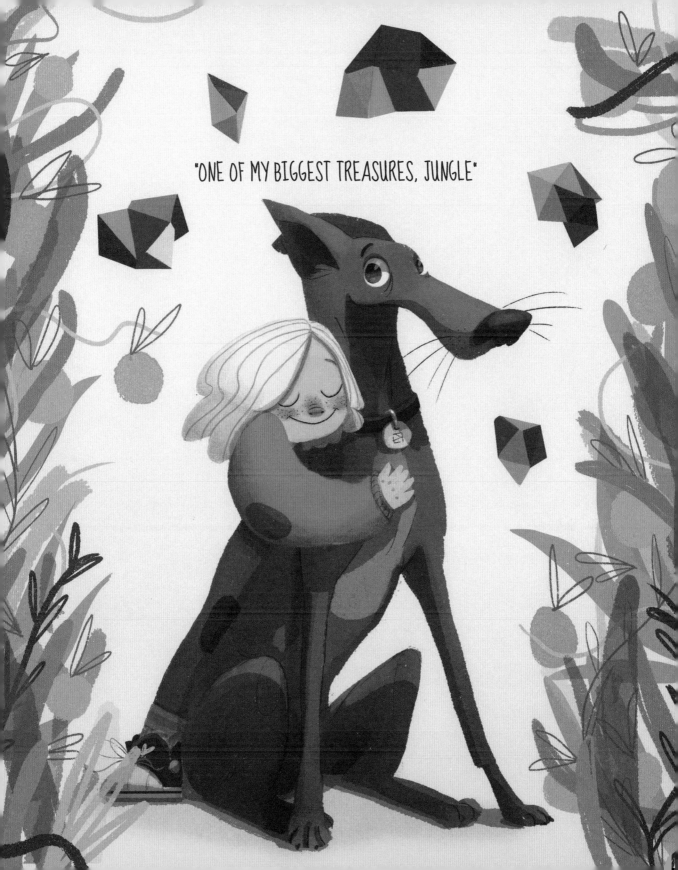

"ONE OF MY BIGGEST TREASURES, JUNGLE"

TREASURES BECOMING STORIES

If you asked me if Treasures are necessary, I would say they're not. But I believe they're inevitable. They're the core of magic. Where everything begins and ends.

It doesn't matter if we're sad or happy, or whether we had a good or a bad childhood. It doesn't matter where we were born or who or where we are. Treasures make us *us*. Our Treasures tell a story about who we are. We can hide that story or show it, but it's there, just like we are there. Our weaknesses and our strengths.

Have you ever suddenly smelled something that has given you goosebumps? Have you ever listened to something that has almost made you cry? Those experiences are some of the Treasures I like to bring inside my glasshouse.

Those Treasures make me want to tell stories. I modify my Treasures, twist them and combine them for anyone that wants to see or read them. And then they become a story.

STORIES AND TALES

I believe good stories are the ones that make you lose all sense of where and who you are for a split second, the ones that make you forget you were ever cold or hungry. Good stories are those that make us believe that whatever we just read or saw could have actually happened, or we wish and hope they had happened. The stories in which anything can be something else from a different point of view. The ones that are a Treasure, and eventually become a Wonder for us.

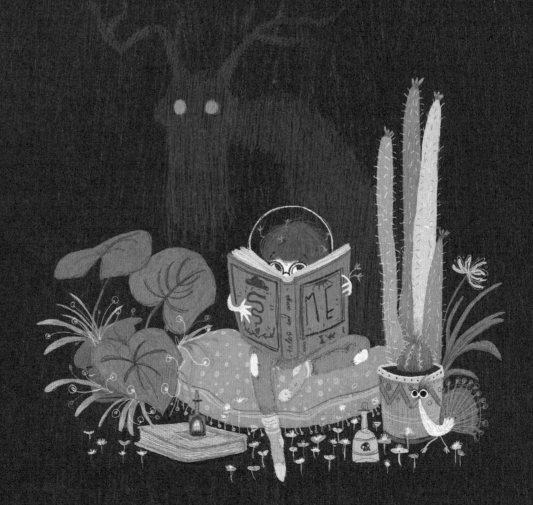

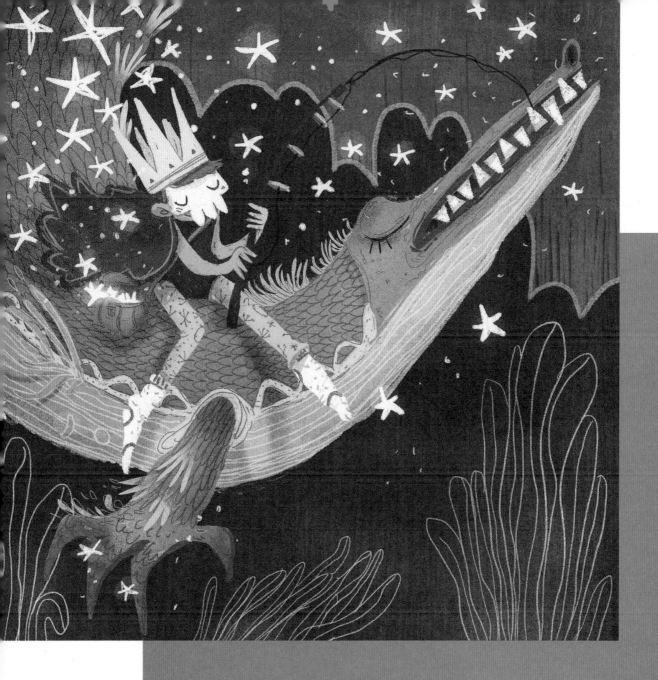

I try to tell stories that come from ideas that might have originated from a feeling, something I saw, or something that was said. Maybe also something I would like to see or that I wish existed. A word I read, a song, a sound, or a thought.

As kids, my little sister Alice and I would read our precious, highly treasured storybooks for hours. We would hide behind the curtain that covered her bed – right underneath mine – and we'd open these books as if they were a golden world to just swim into.

Stories by great writers such as Neil Gaiman, Roald Dahl, the Brothers Grimm, Charles Perrault, Hans Christian Andersen, and Jean de la Fontaine inspired me hugely. As well as fairy tales, I love poetry, and enjoy the works of Rupert Brooke, Pablo Neruda, and so many others.

I am also a big fan of the work of writers from the Beat Generation, including Jack Kerouac, Gary Snyder, and Allen Ginsberg, as well as other classic writers: Walt Whitman, Mark Twain, Charles Dickens, and my beloved Oscar Wilde.

What inspired me most about the stories I delved into was the Wonder; the way the authors describe things, the way they make you go deep into their thoughts or their way of seeing things.

You become engulfed in the characters and the journey of each story, as short or long as they may be.

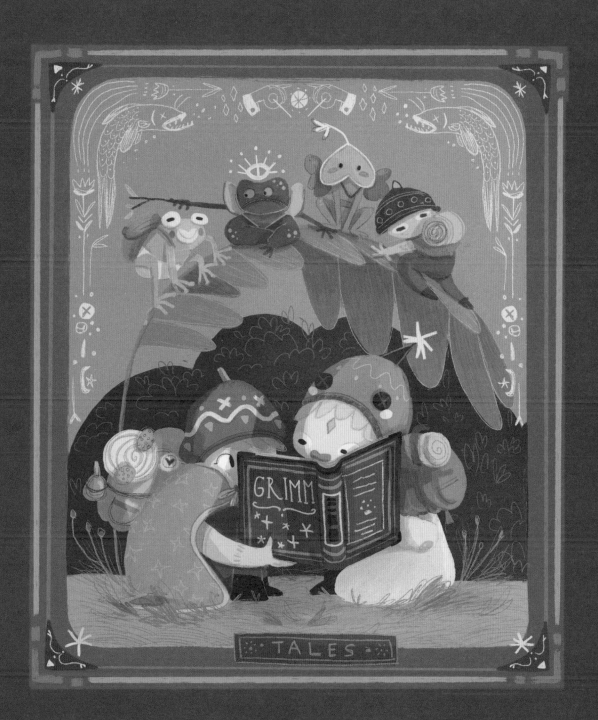

"THROUGH MY ART I HOPE TO TELL TIMELESS NARRATIVES THAT WILL BE ENJOYED FOR YEARS TO COME"

Through my art I hope to tell timeless narratives that will be enjoyed for years to come. It's one of my biggest and most challenging goals. That's another reason for my constant experimentation. My aim is to create something new and fresh by talking about my values, without losing any of the magic.

I try to work with all the elements of the illustration or design so that they all help enhance the final story I want to tell. I consider composition, the view from where I would like to see the image, as well as color, shapes, lighting, and any tiny post-production techniques I might use to tell the story more clearly.

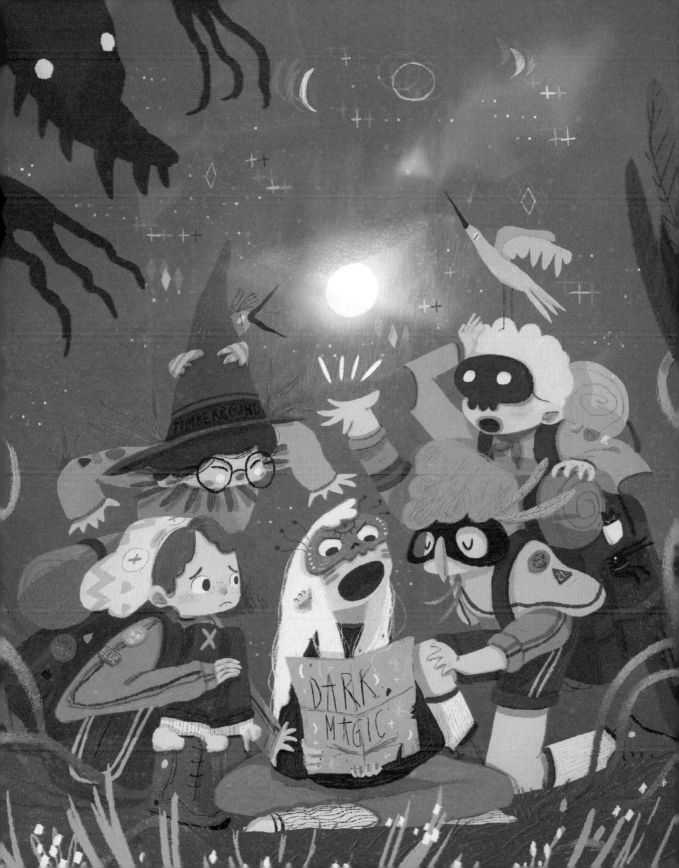

I want people to have fun while reading, seeing, or listening to my stories. There are so many things to be told and so many ways in which to do so. I love to explore the endless possibilities to try to discover the best way to connect to the viewer to make them feel and/or imagine something they would not feel or imagine otherwise. This is a superpower I'd really like to have.

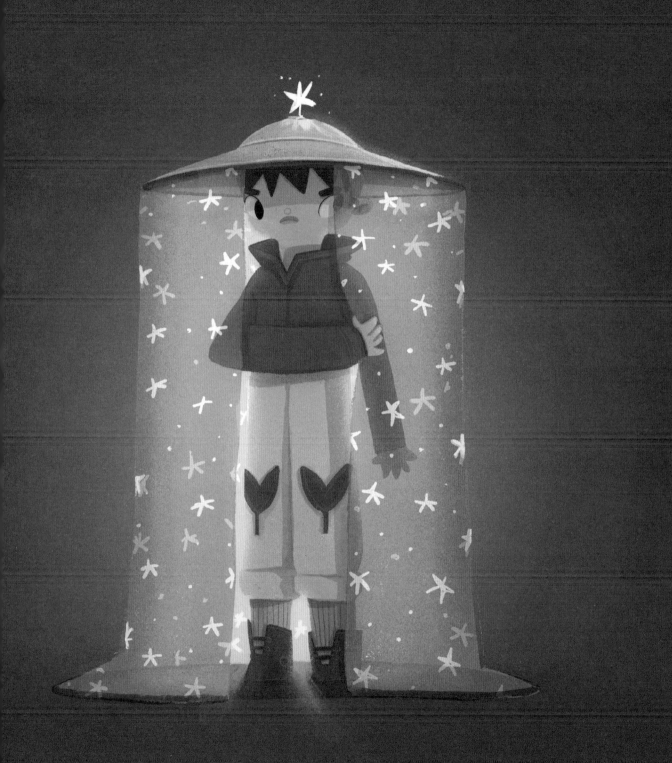

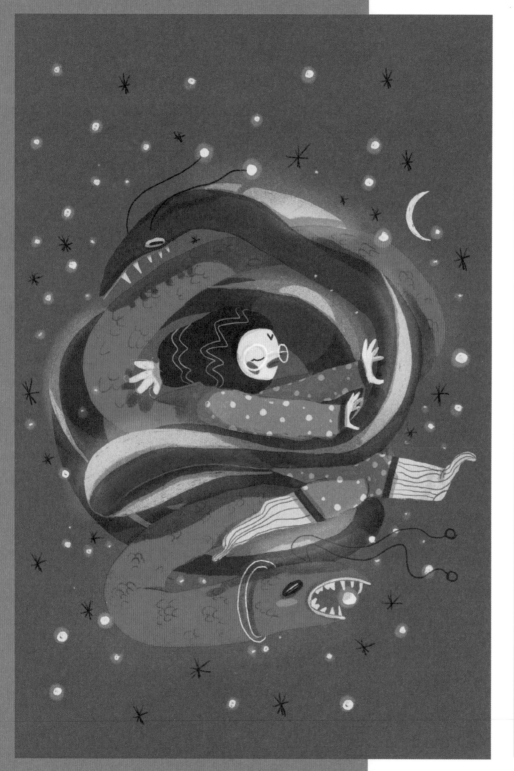

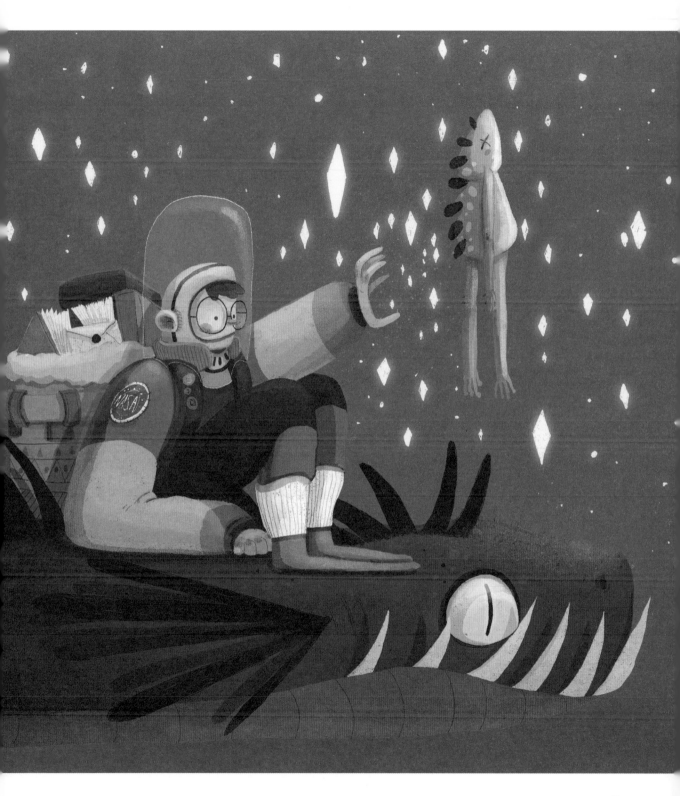

STUDIO

My studio has been located at home for the past three years. While living in Montreal, I also shared a space with some amazing artists.

Being freelance allows me to manage my own time and explore a little bit every day with my doggy, Jungle. I also love working at studios for big projects and being part of a team. A balance of the two is perfect for me. I try to maintain adventure as part of my daily routine.

DAY-TO-DAY

After waking up and a family hug, there's usually coffee, followed by answering emails. After that I draw, paint, or write until midday, unless I have meetings. Then the first adventure time is here!

Jungle and I go exploring for about an hour. Sometimes we fight with the snow, lie down and smell the flowers, or stumble across new Treasures. Recently I found an abandoned handmade wooden birdhouse!

After that I keep working until about 5.00 pm, when we go exploring again!

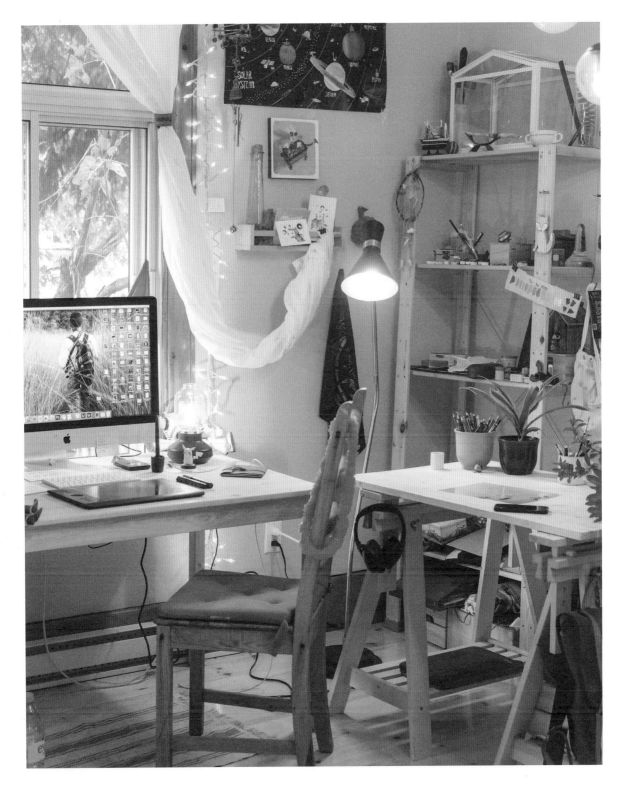

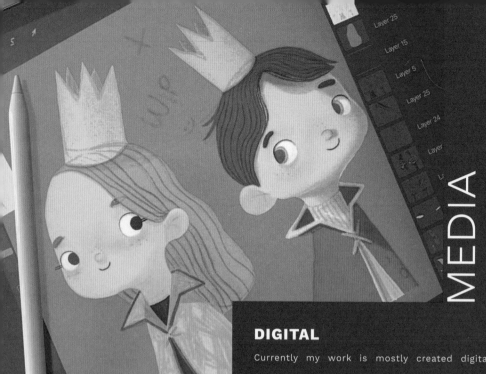

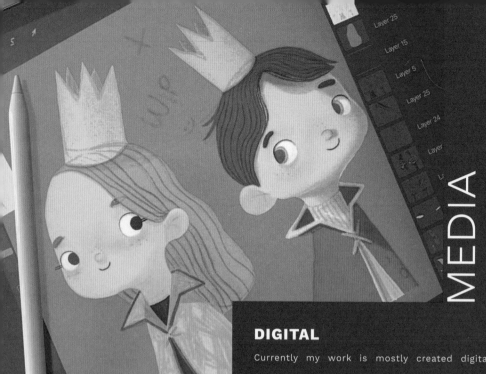

MEDIA

DIGITAL

Currently my work is mostly created digitally, although I'm trying to work more traditionally little by little, to keep a balance of the two. I tend to leave traditional art for my most personal things or to just relax a bit, whereas digital art feels easier and faster to apply feedback to, and is more efficient for my work at the moment.

The iPad Pro has made a huge impact on my work routine. To be able to do everything on a tiny, almost weightless device, anywhere you go, still feels out of this world. As for a desktop device, I couldn't live without the colors of my iMac now, so I work with a graphic tablet instead of any other screen-painting devices.

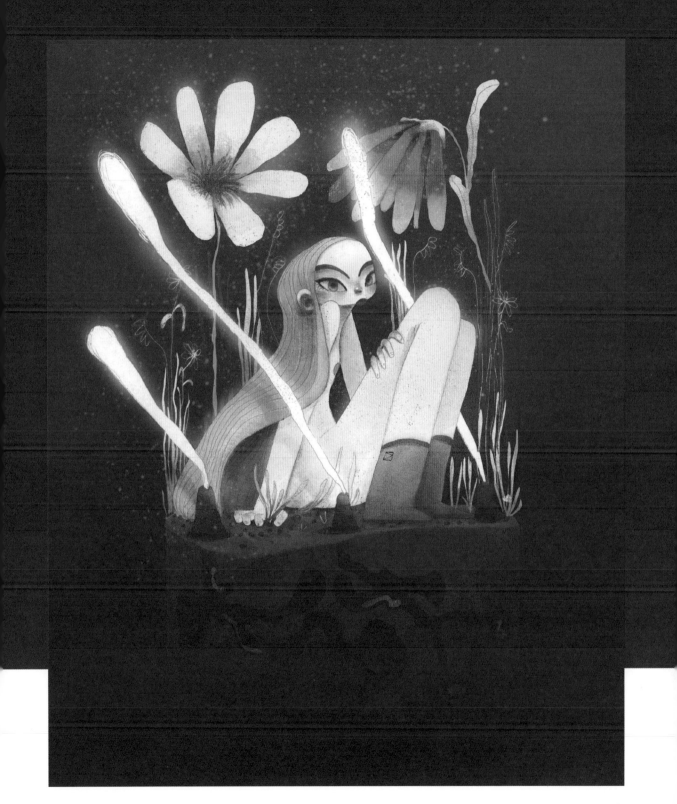

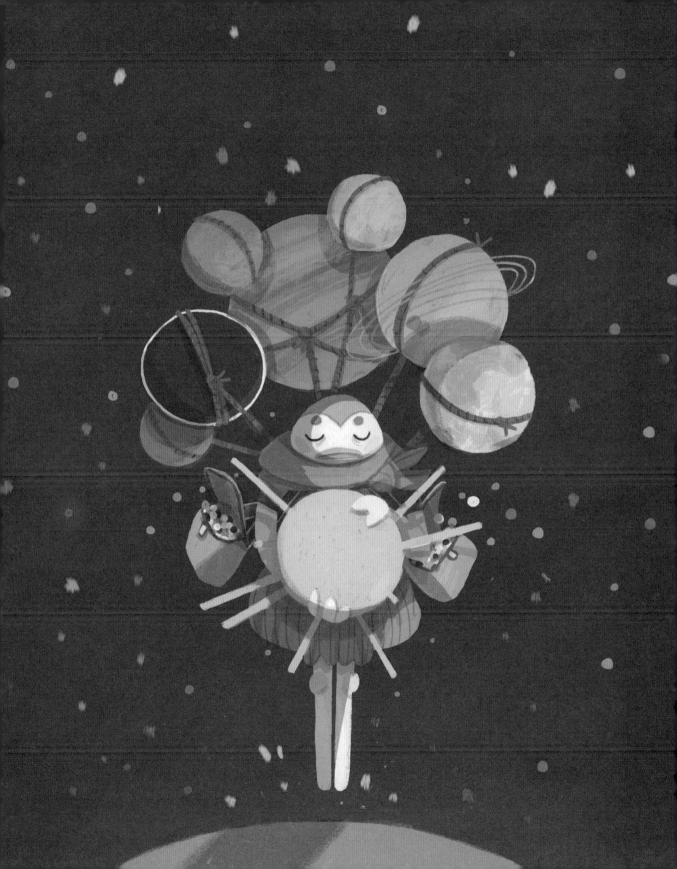

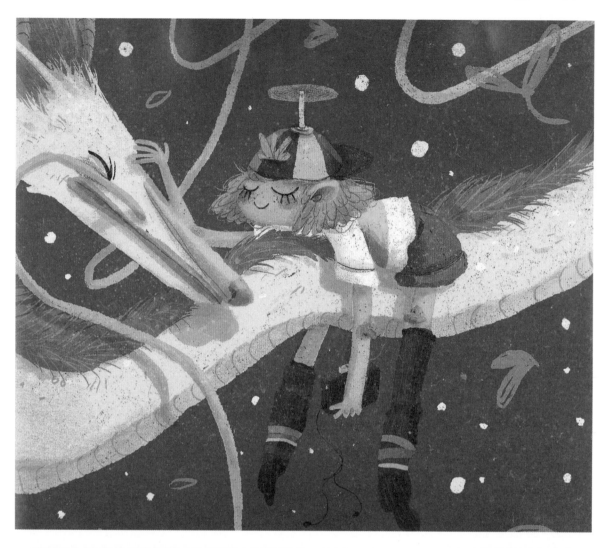

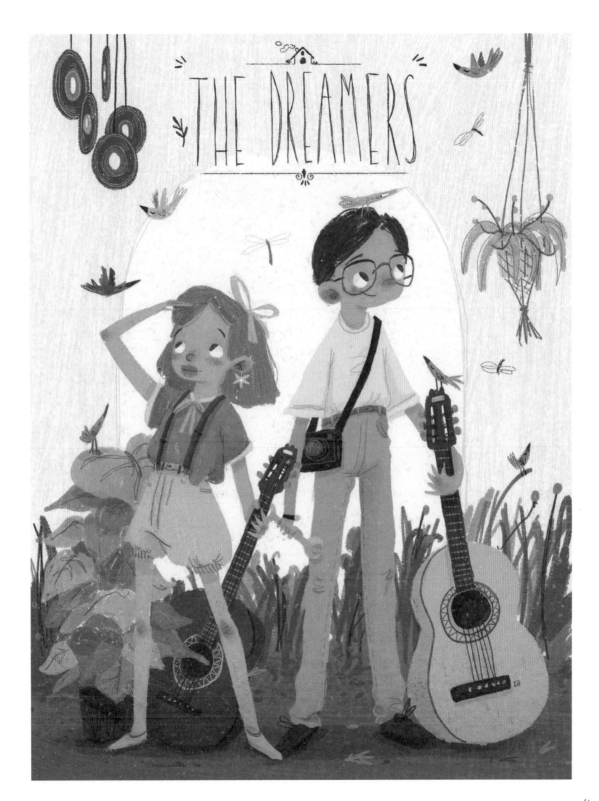

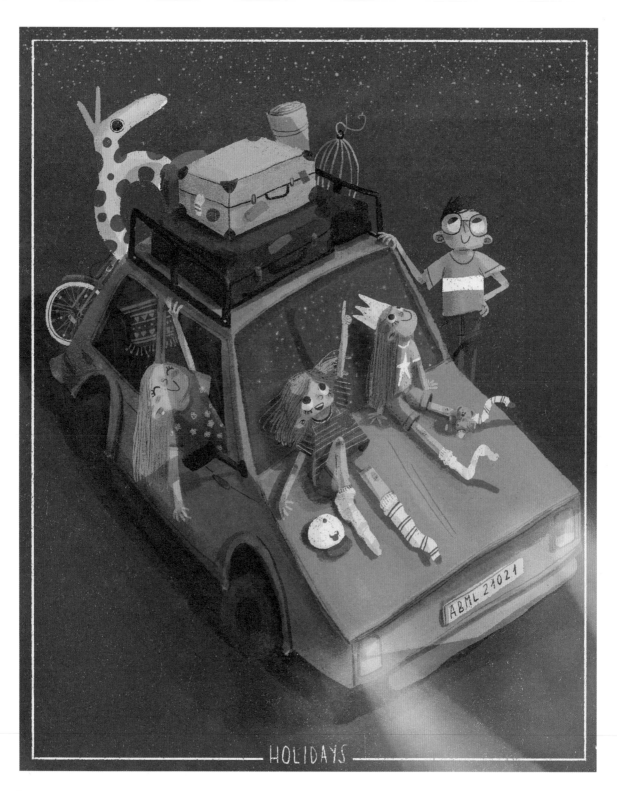

HOLIDAYS

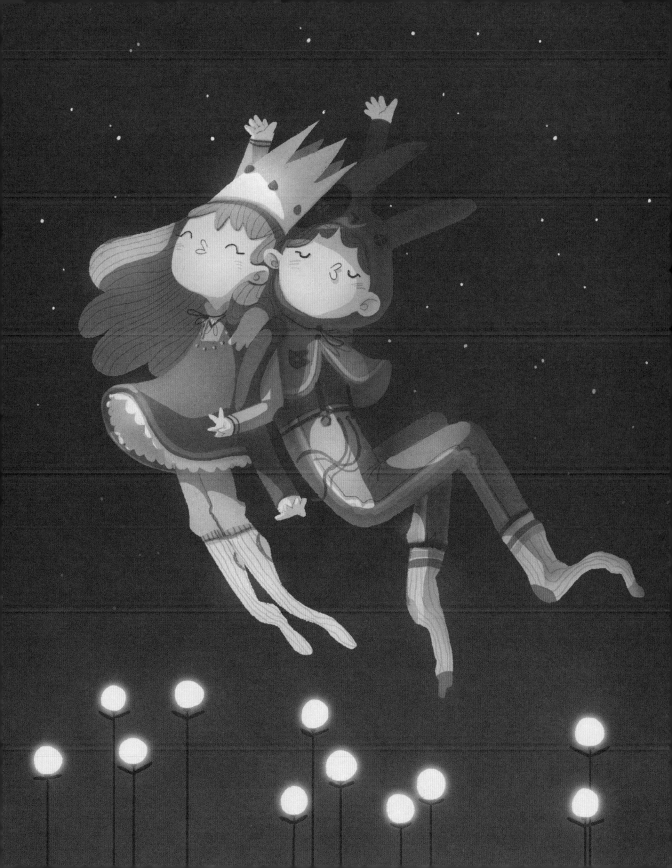

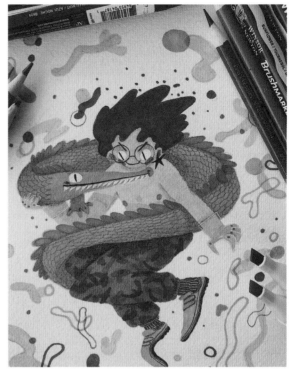

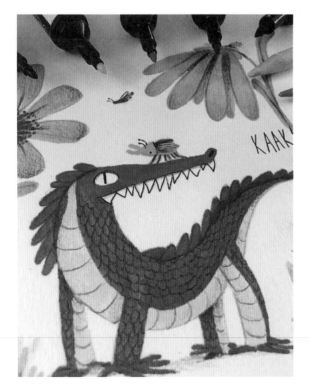

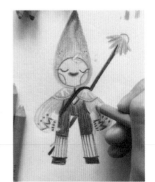

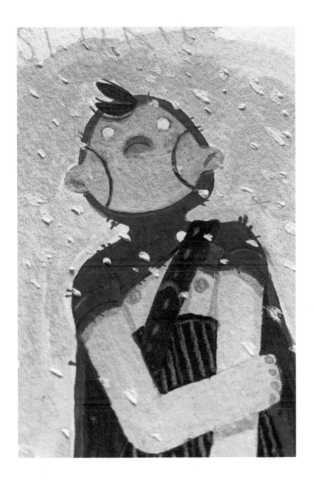

TRADITIONAL

I enjoy every aspect of working with traditional media – the interaction with the elements, testing and making mistakes, and the beautiful textures and sounds. I take joy in the fact that decisions have to be made that sometimes cannot be undone.

Every creative decision is important and has to be accurate. I love it but I'm also scared of it, which makes it perfect for me because it becomes more of a challenge.

Currently I'm enjoying mixing traditional media, with my preferred combination being watercolors, markers, or gouache as base colors with colored pencils or crayons on top to create layered deliciousness. But I'm always searching for new ways to mix media!

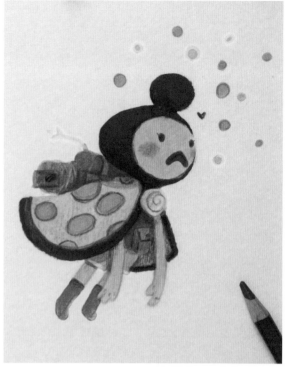

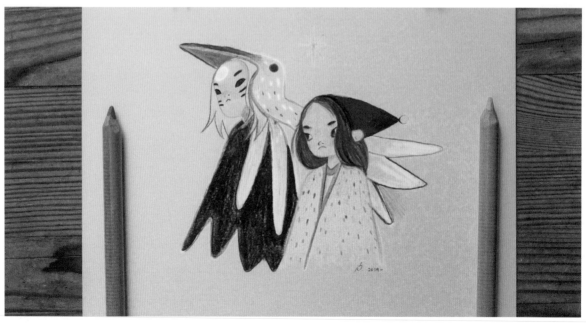

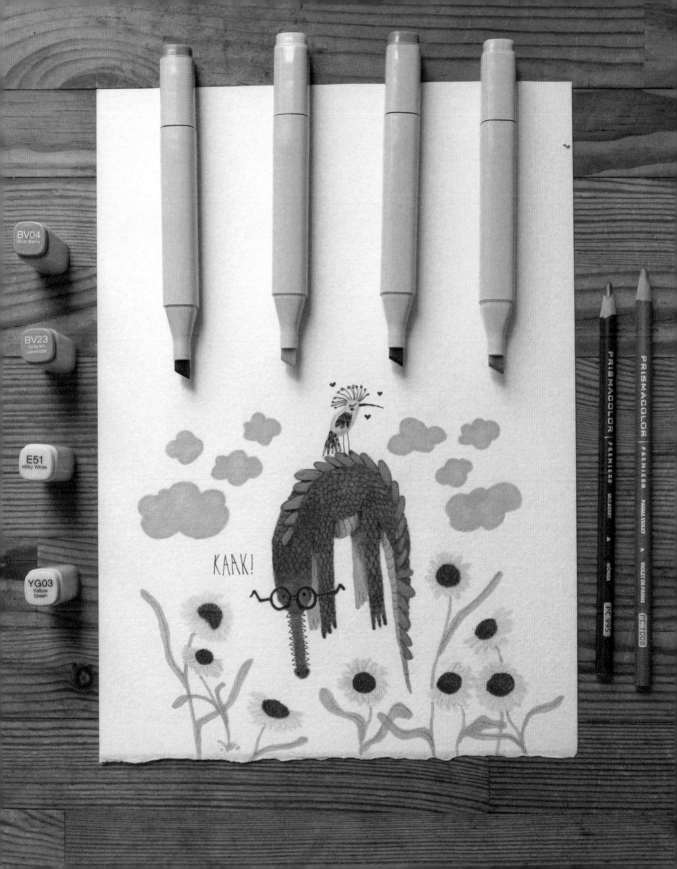

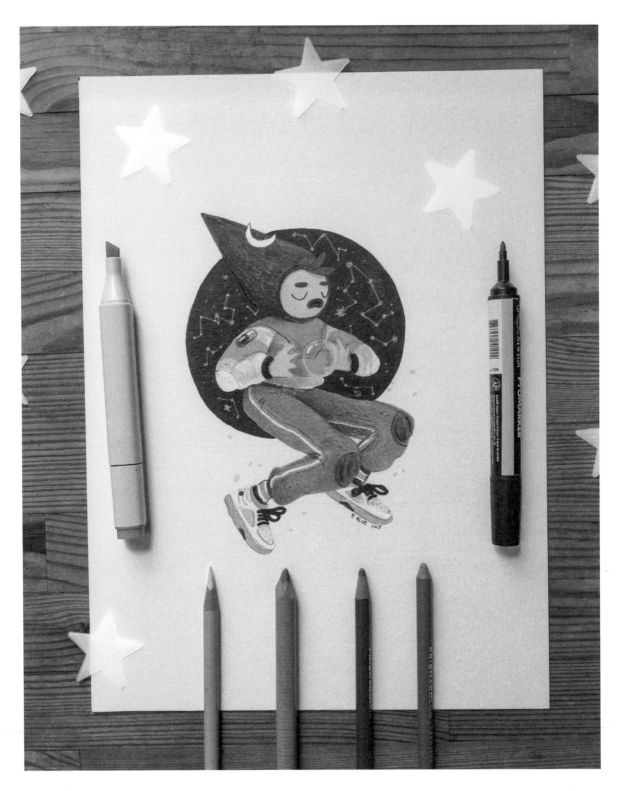

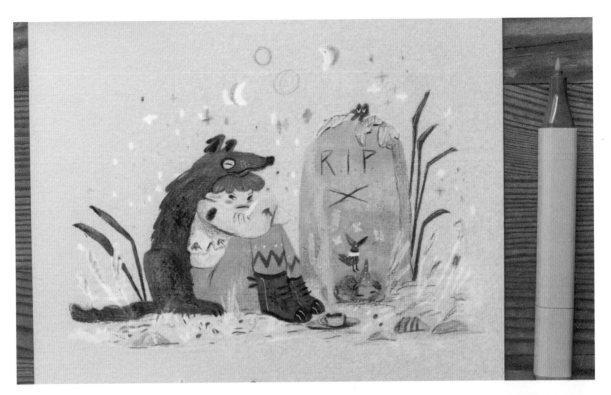

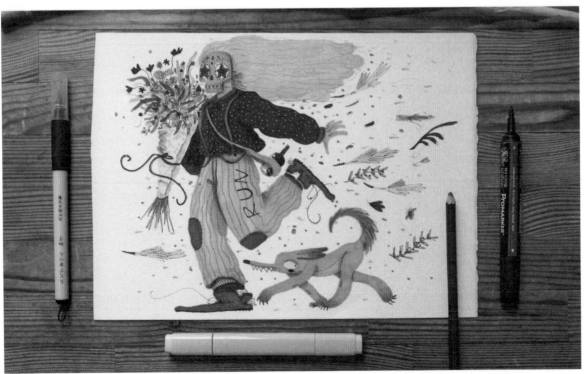

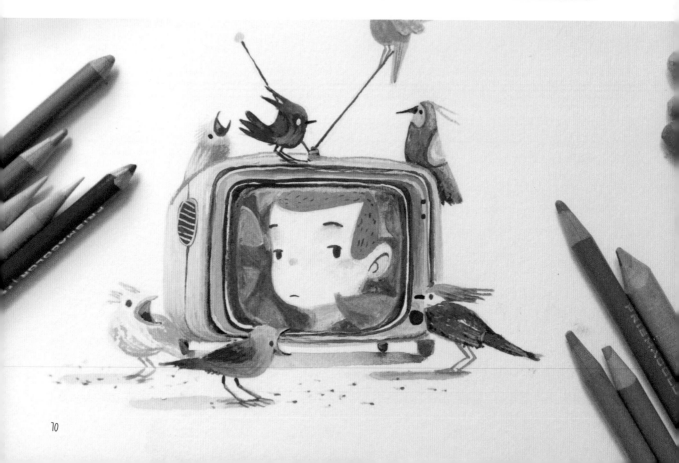

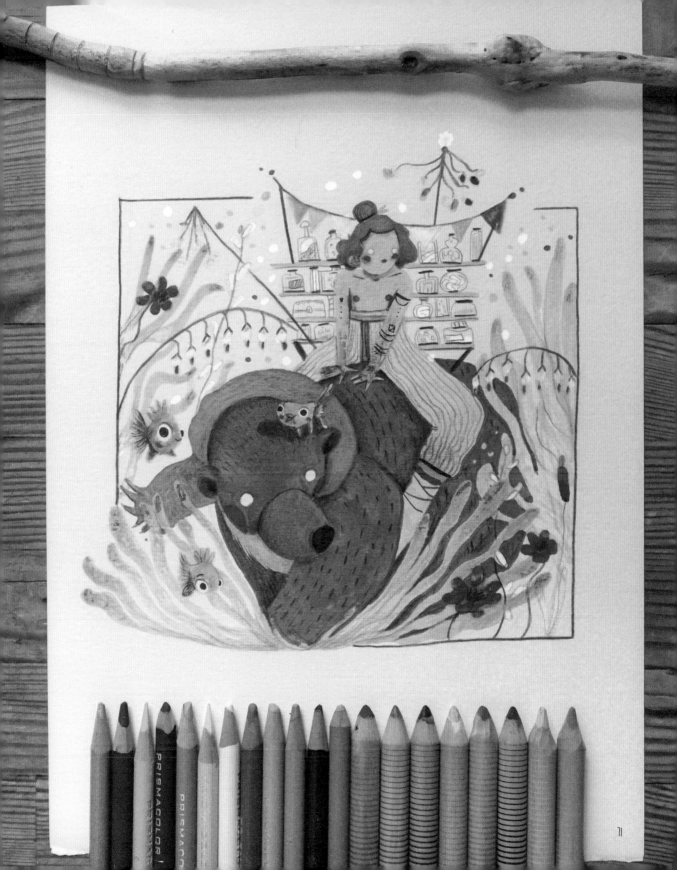

SELECTING MEDIA

Digital media offers time and control in places where traditional media does not. It is a different media, not a substitute. I couldn't compare digital and traditional media without saying that they are distinct from one another.

One similarity is that digital media can give you a small taste of some of the traditional tools by using different brushes.

Using digital media is an entirely different experience to me, and doesn't feel like traditional media at all. I find pleasure in developing new approaches to all tools and techniques, whether they are digital or traditional; they are all individually special to me.

One form of traditional media that I have experimented with extensively in the past is watercolors.

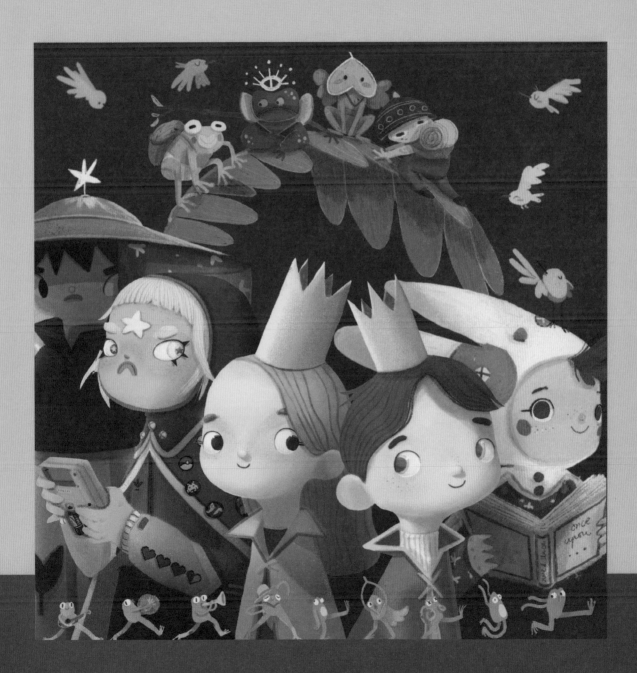

WATERCOLOR ALCHEMY

Pigments are fascinating things. When I was a kid, I used to store dust inside tiny empty perfume bottles my grandma gave me. They were some of my most precious Treasures.

It amazed me to discover that you could buy pigments from art stores and make your own paints. So, I read a lot about it, and then started to try it myself. As far as I've tested and read, I've been able to make watercolor paints using just water, pigment, and binder. You can either buy the binder ready-made or make it yourself.

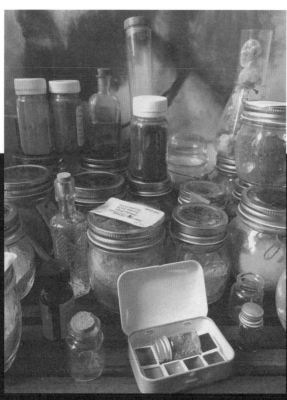

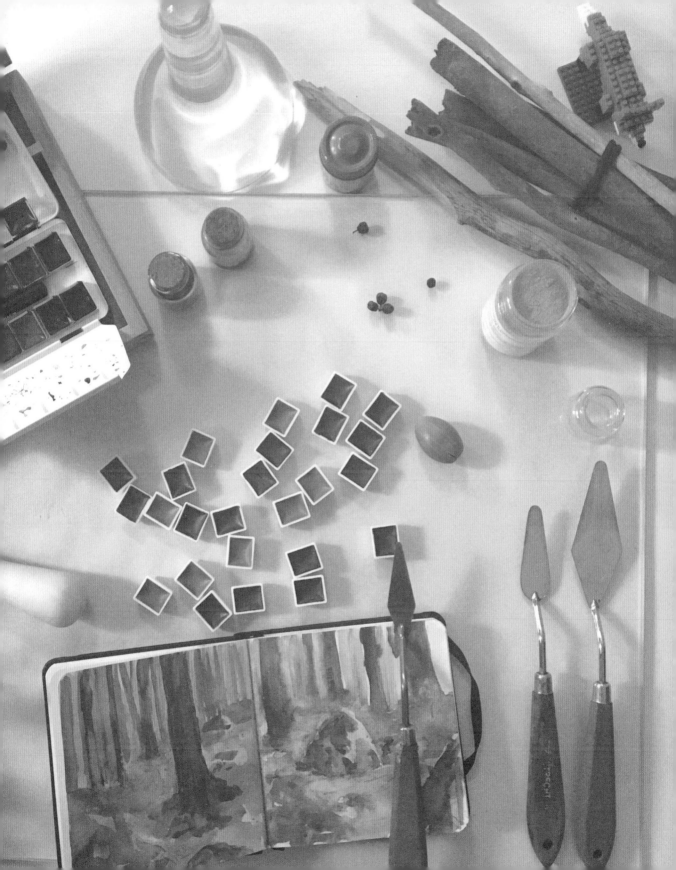

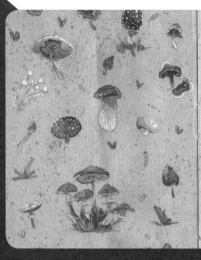
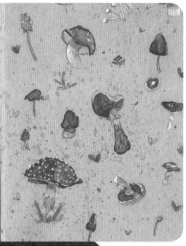

"I CAN MAKE THE EXACT COLORS THAT I WANT AND THERE'S A FEELING OF MAGIC AND MYSTERY WHEN MIXING THE POWDERS"

Dani and I collect pigments from the different locations we travel to. Sometimes we buy them and sometimes we capture them from natural sources such as rocks, sand or natural clay. We then use them to make our own watercolor palettes.

I can make the exact colors that I want and there's a feeling of magic and mystery when mixing the powders, seeing how they behave with the binder, writing down notes, measuring quantities, and keeping bits of color to remember nice mixtures. I believe the hues of handmade watercolors are richer and more vibrant. I also produce much more paint than I need, which often means gifts for friends!

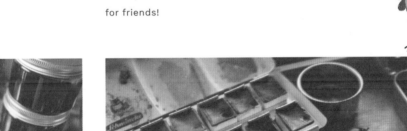

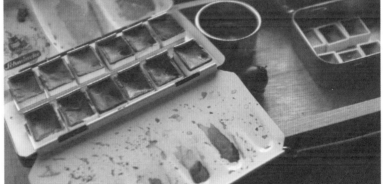

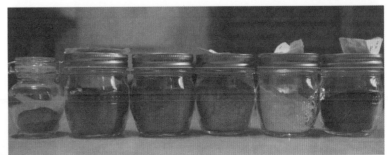

CREATIVE PROCESS

Sometimes I start a design with just a vague idea. Other times I draw shapes or try out a few colors, and ideas are born from that explorative play. To develop my initial thoughts into tangible designs, I consider many aspects, including composition, narrative, color, light, form, type of rendering, media, and texture to try to make sure I convey that idea in the best possible way.

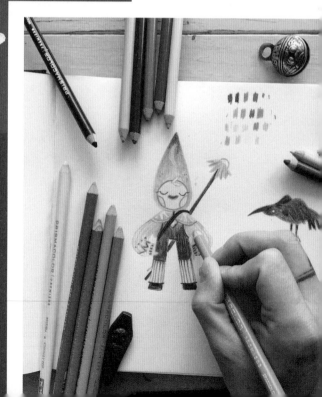

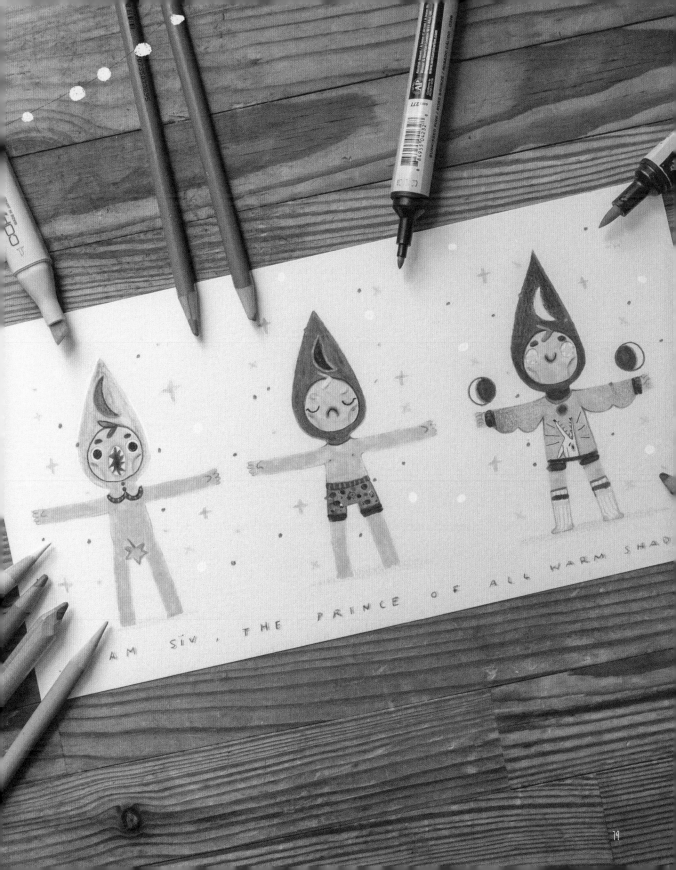

AM SIV , THE PRINCE OF ALL WARM SHAD

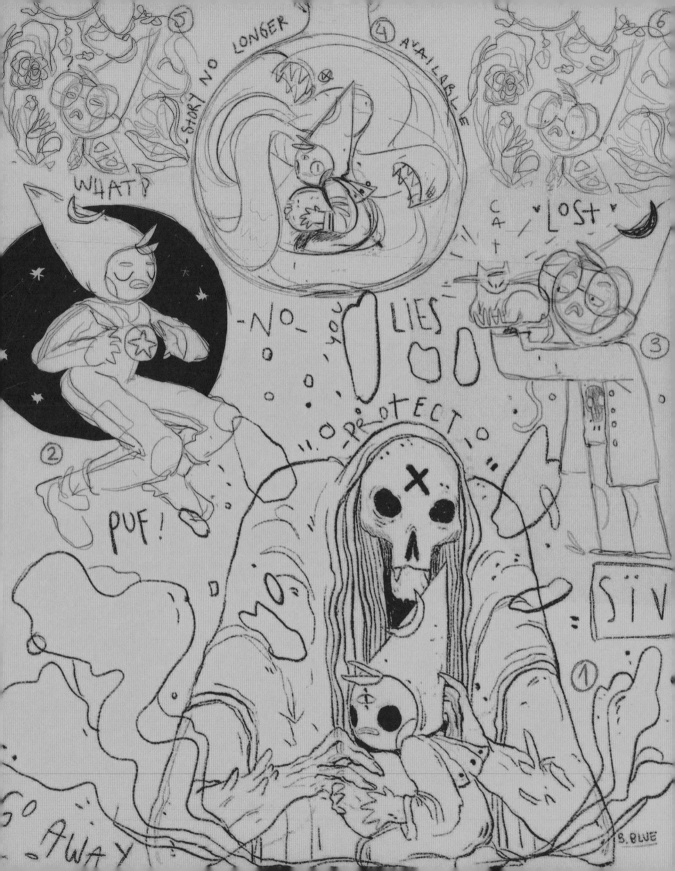

B. BLUE

I carry a sketchbook with me at all times – it's great to be able to test out new shapes on the go and learn more about form and line through practice. Drawing everything that you might be afraid of drawing helps to keep the mind fresh – it may cause frustration and highlight things to work on and overcome, but it all contributes to a faster evolution.

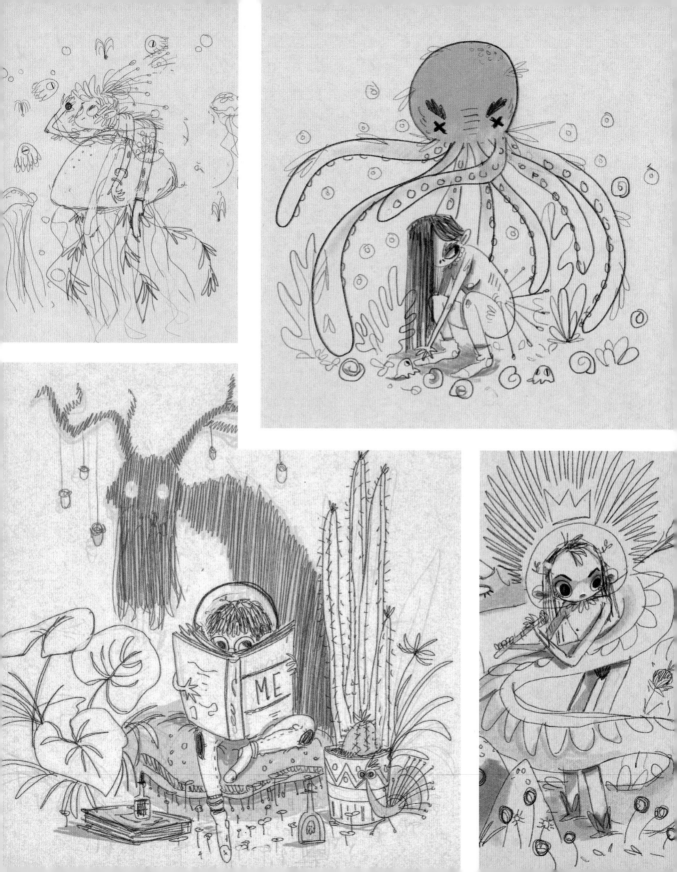

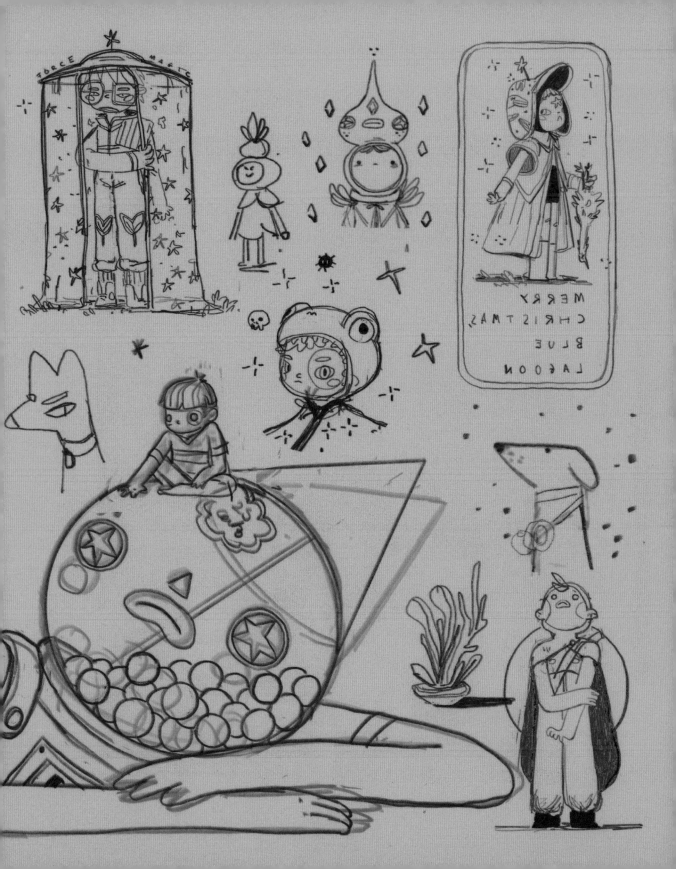

INK

The first time I worked with just ink was when Dani and I completed the Inktober challenge together. I'm still not entirely comfortable with it.

I'm starting an ink sketchbook to explore forms and to try and keep my sketches fresh. I think and hope it will help develop my line skills a little bit too.

I add color because using just ink feels strange to me. I find it difficult to think in black and white.

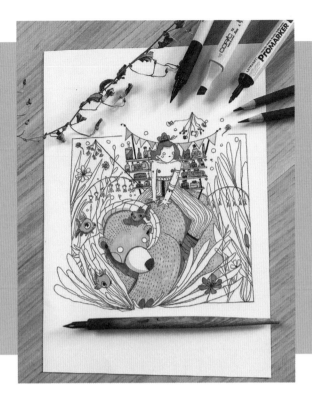

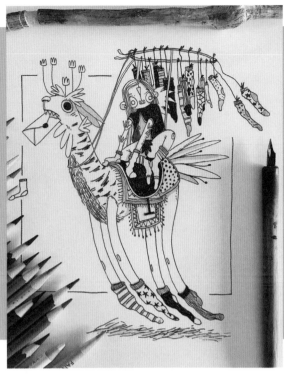

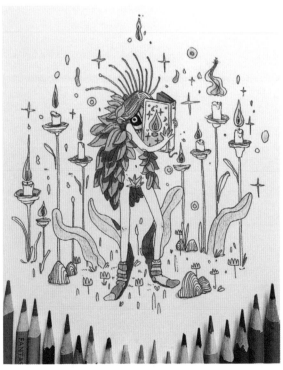

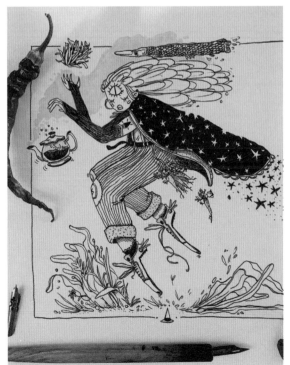

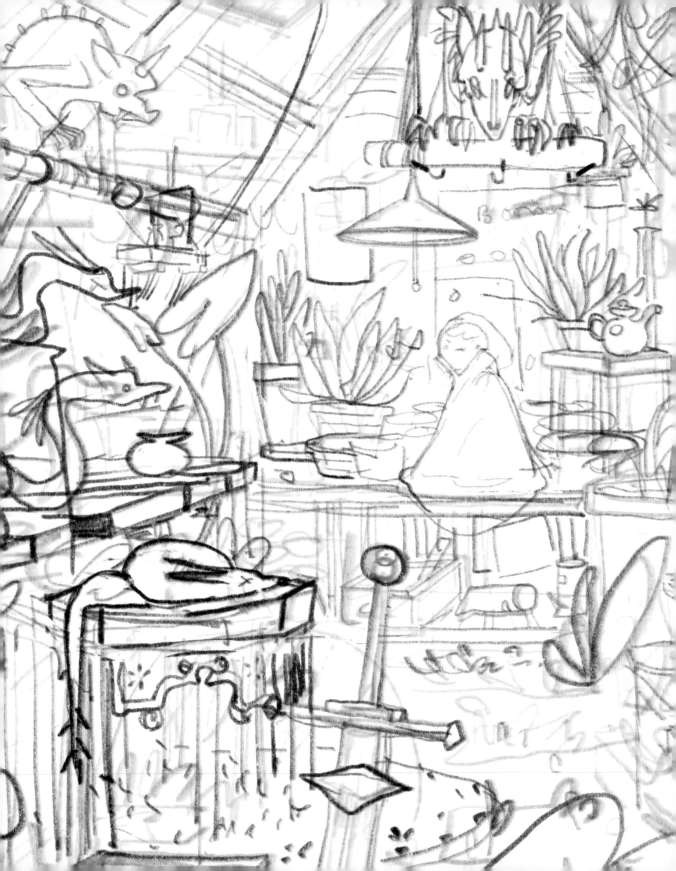

COMPOSITION

When approaching composition, I consider black-and-white values and their amount, position of objects and their balance within the whole image, balance of color around the image, and how to guide the viewer through the design using colors, shapes, and negative space.

I also employ compositional rules, including the rule of thirds or the golden spiral, to work out if the image is visually balanced.

COLOR

I like to take extra care when selecting a color palette for a design. I usually consider a few things: the mood of the image, the lighting I'm going to apply to it later, the narrative, overall composition, and the focal point.

Testing different color combinations and their reaction to different lighting is always so much fun. I've recently been enjoying vivid cadmium reds with yolk yellows and light or dark gray, but usually I try to vary my use of color and not get attached to one single palette – there are so many colors and combinations to play with!

After looking at some of my previous work, I try to make something a little different to push myself in new directions. This does, however, depend on whether it is personal work or commissioned work, as I might be asked to take other design elements into consideration.

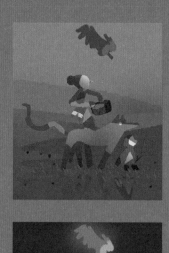
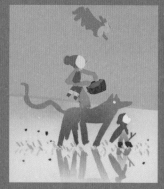
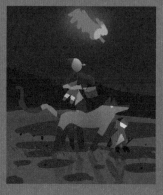
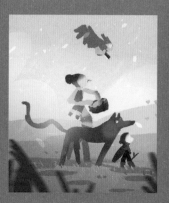
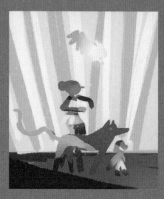
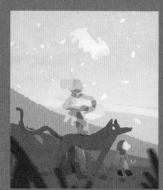

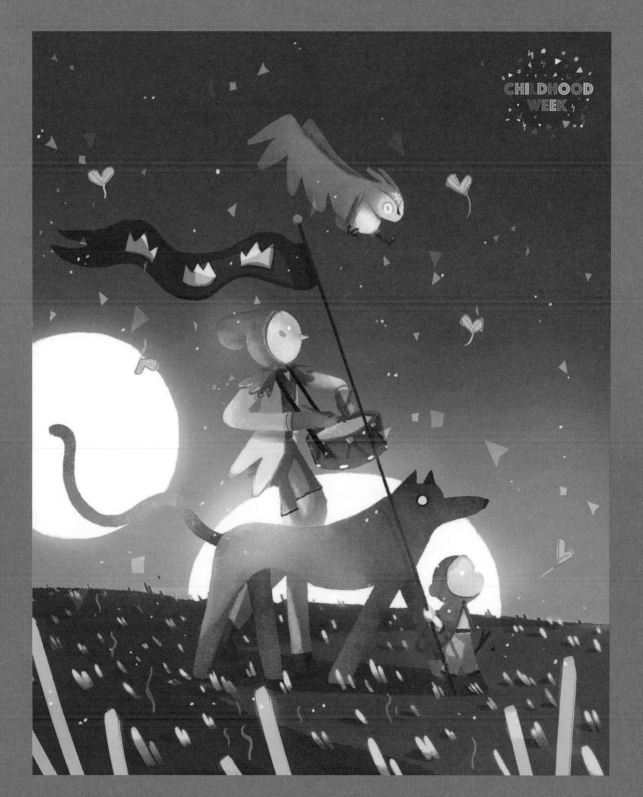

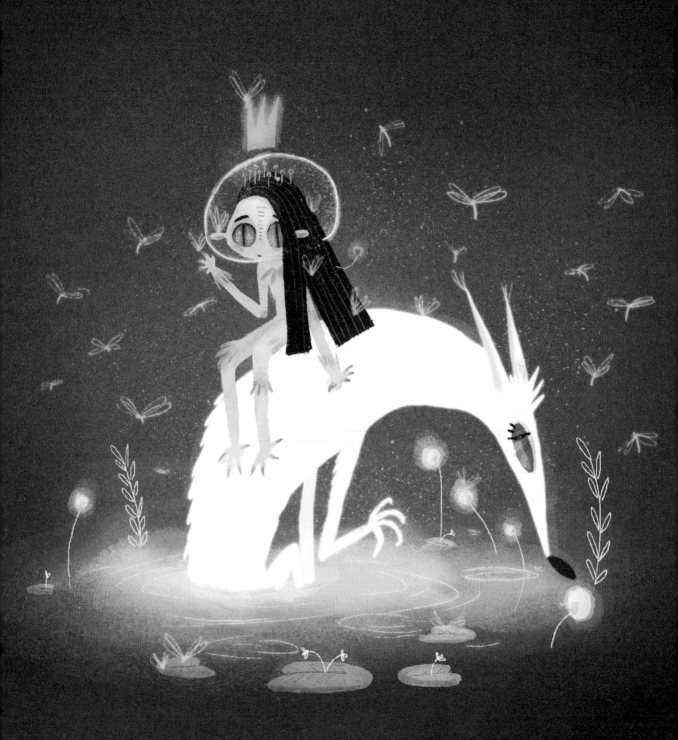

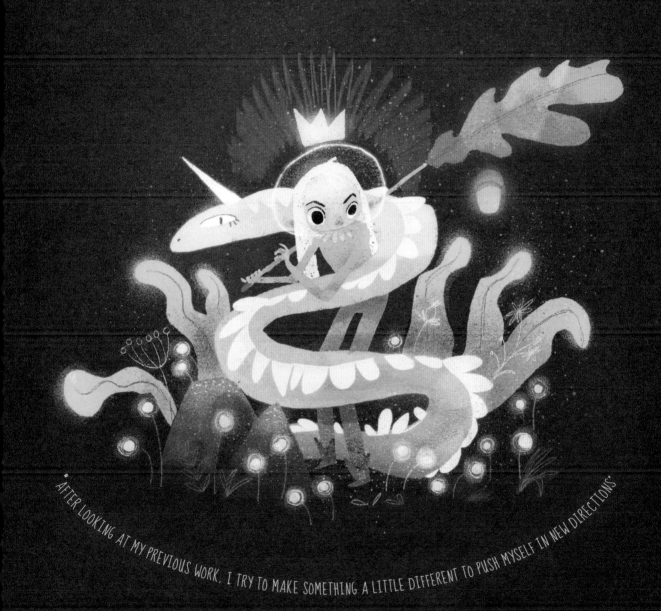

"AFTER LOOKING AT MY PREVIOUS WORK, I TRY TO MAKE SOMETHING A LITTLE DIFFERENT TO PUSH MYSELF IN NEW DIRECTIONS"

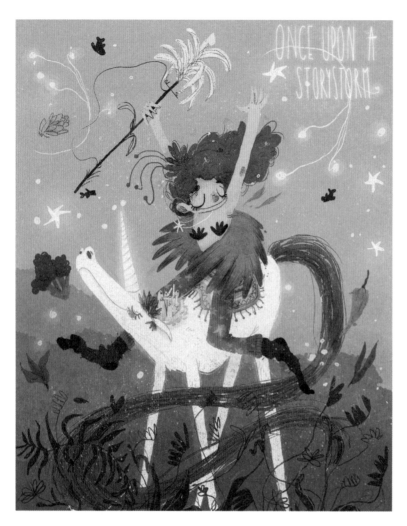

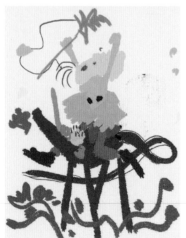

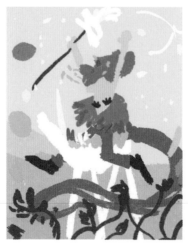

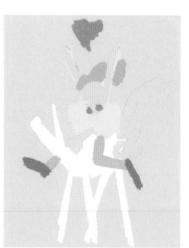

SELECTING COLORS

Besides illustration, I also enjoy creating color scripts and color keys for films and picture books.

Every project has a mood timeline and it is amazing how color and light affects us visually.

COLOR DEVELOPMENT

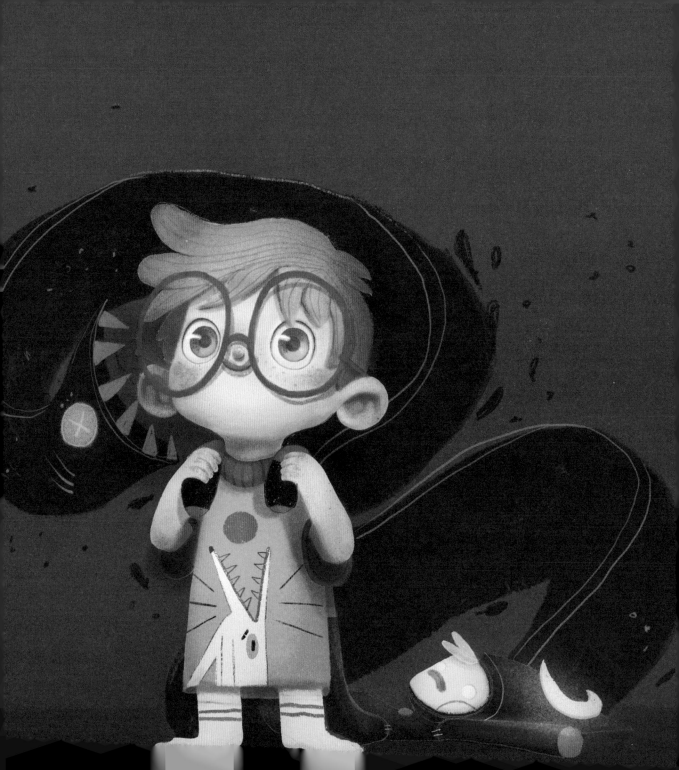

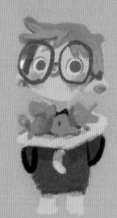

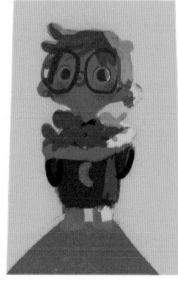

I have always had a passion for color, so it is important to me that I make the right color choices for each artwork in order to portray the mood and narrative effectively to the viewer. I challenge myself constantly to experiment with new palettes and new ways of lighting the design, to understand the different ways the same visual story can be told.

DESIGN DEVELOPMENT

THE IDEA

There are three methods that I use to help me find what I want to draw.

One is to take a sketchbook and start exploring forms or colors until I suddenly like something which looks like it has the potential to become an illustration, character, concept, or sometimes even a much bigger project.

Another method is to take several things I enjoy drawing and try to make them work on paper. It could be a character I thought up, an illustration, or even a book.

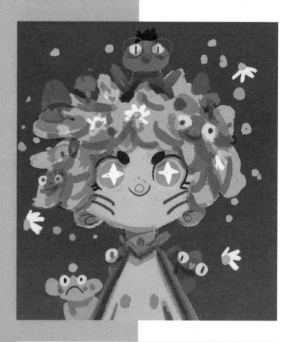

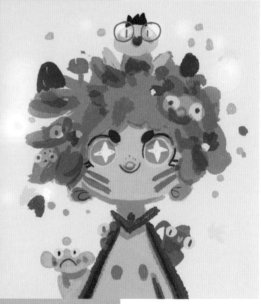

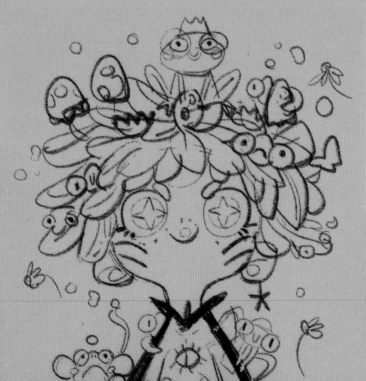

FROG

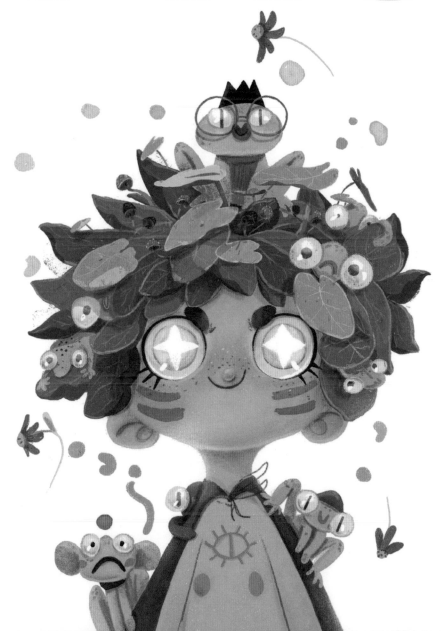

I find this approach the most challenging because it requires a bigger comprehension of what I want to do, and most of all, it requires something super important: translating with my hands what's inside my head. In this case, writing a small list of requirements helps me to keep on track and not to diverge into other concepts that might appear along the way.

Sometimes letting myself wander is great too, but it can be very frustrating as well, since I end up forgetting what I wanted to develop in the first place.

The last technique is just going outside and painting from life. This is something I enjoy doing as often as possible because I learn so much every time I do it.

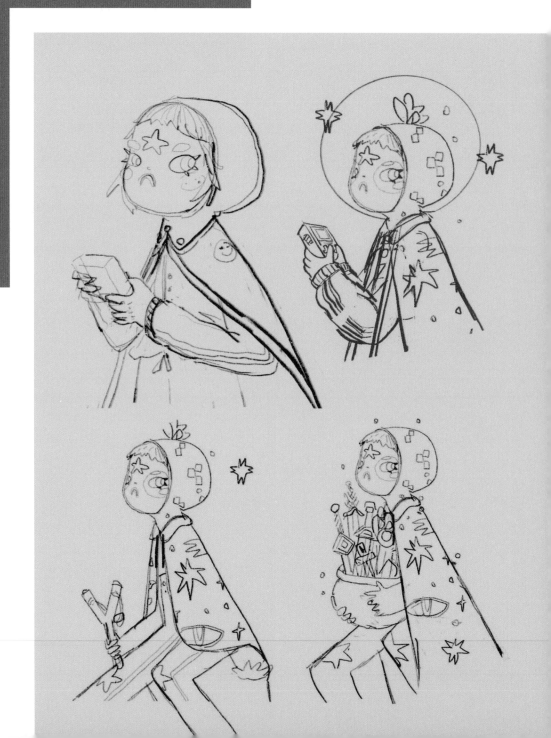

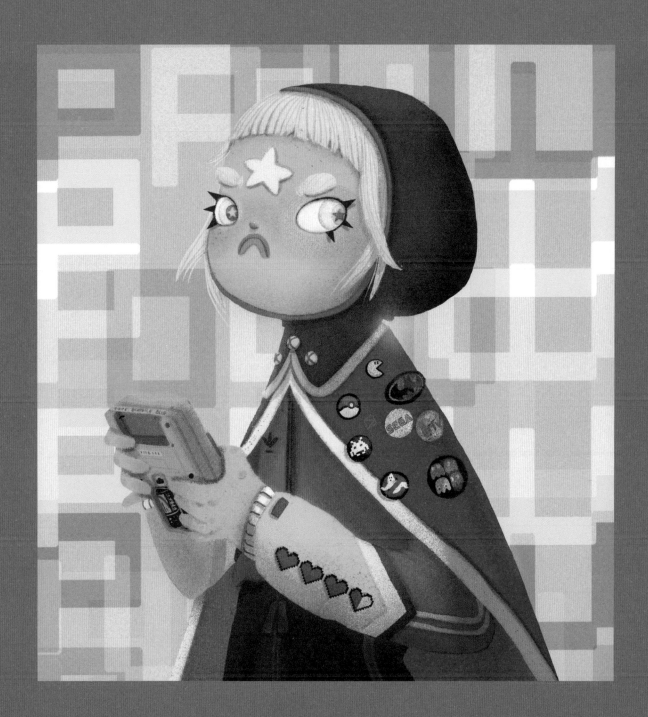

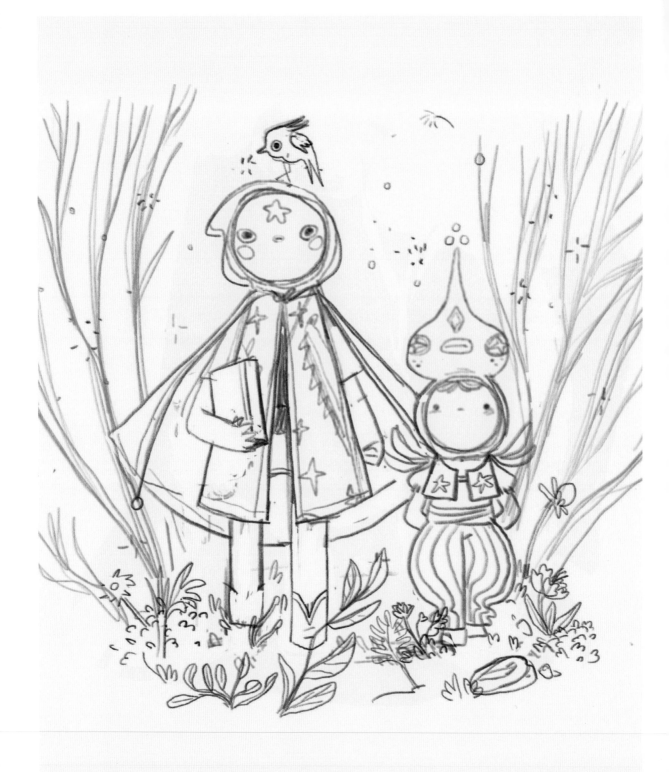

DESIGN IN PRACTICE
MOOD-FORM-STORY

To develop a new piece of art to accompany this book, I started with an existing idea: two unique characters, created especially for *Wonder*. I began with the initial idea of sisters, with a gender-neutral appearance and strong elements of Wonder and solemnity.

I started exploring designs. Testing shapes is always fun – there are so many ways to express the same idea. At this point, I force myself not to care about whether the drawings look good or bad, and instead concentrate on showcasing the idea, mood, and story that I want to tell.

There are so many things to consider when it comes to creating what I have in my mind, and sometimes it can be overwhelming, so I try to keep it as simple as possible at all times.

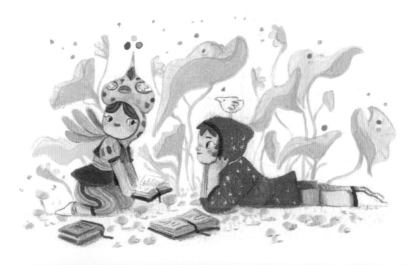

TRADITIONAL OR DIGITAL?

The next step of my design process is to consider what sort of outcome and render I would like or is required for the artwork. I then decide whether to create the piece digitally or traditionally.

When it comes to personal work, I don't limit myself or follow any specific rules, I just intuitively follow what I feel like making, in whichever media I desire.

However, if I am working on a longer project, I tend to choose to work digitally to streamline changes in the post-delivery stages.

Working on lighting in digital media is also more accurate and changes are actually feasible, unlike traditional methods, where alterations can be laborious and time-consuming. In my digital personal work, I often use textured brushes. I enjoy the traditional feel that textured brushes give to a painting, as well as an additional element of fun and interest.

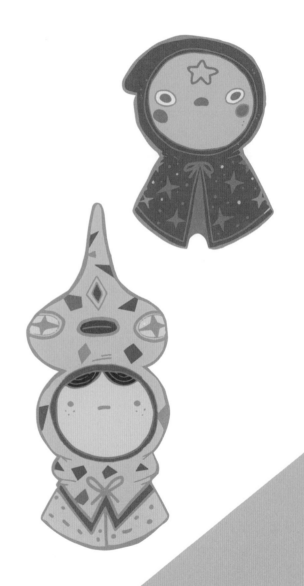

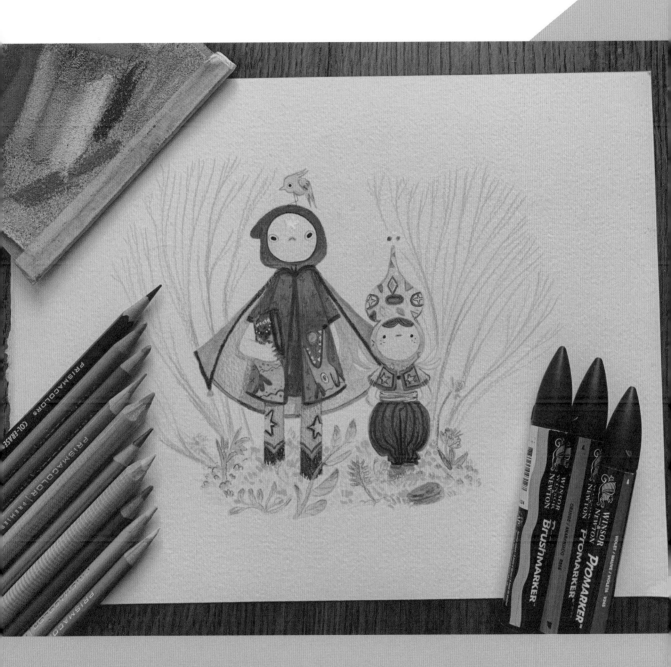

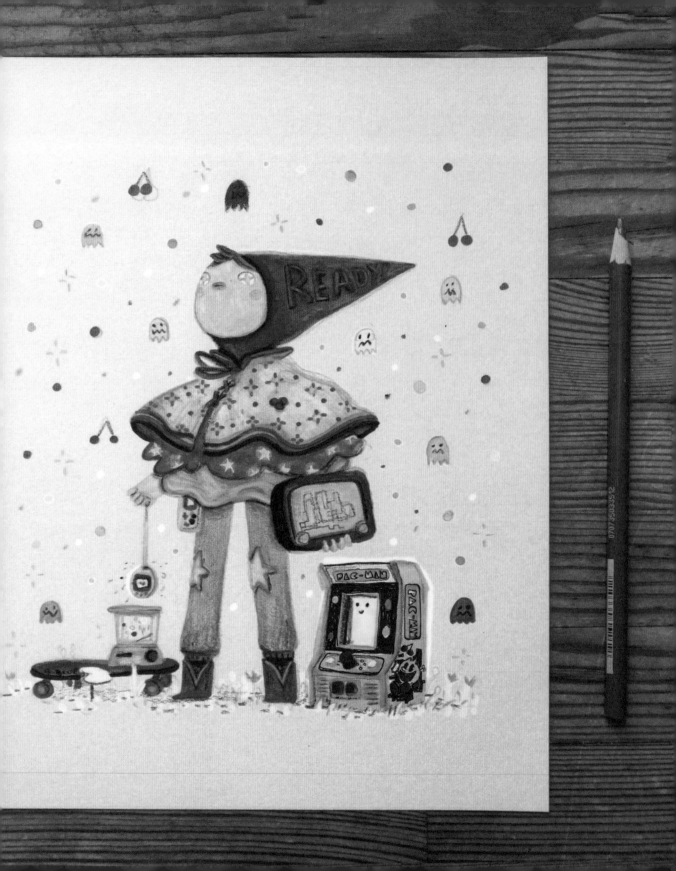

DESIGN IN PRACTICE
TRADITIONAL MEDIA

Once I knew I wanted to draw the characters traditionally, the next step was to decide which type of traditional media to use.

I love exploring all sorts of materials and being curious about what a new combination of media might look like. So, from time to time, when I feel like I could try something new, I force myself to go to an art store or search around my supplies and pick two materials that I would love to try (one marker and one ink pen, for example) and then try them out. It's very hard for me to do this, as I always put so much pressure on myself. I feel that everything I do has to be better than the last and has to teach me something.

For this exercise, it helps me to think that nobody is watching and that I'm just doing it for myself. And it works for me. Little by little I gain confidence with that media and I can acquire it as part of my tool kit if I end up liking it.

COLOR TESTS

Before embarking on a final painting, I usually do a few color tests to find out not only which colors work best for my drawing, but also to let go of most of the potential possibilities and prevent losing myself in the design process.

Color tests give me structure, which makes me feel more secure, but they can take away some of the spontaneity that I enjoy.

When I have a color test, I can focus on bringing out the textures and exploring the materials, and it's easier and faster if I'm streaming because I have already made some design decisions.

If I'm painting for myself, just for fun, I like to keep it messy and explore in every step, risking every decision into a potential disaster.

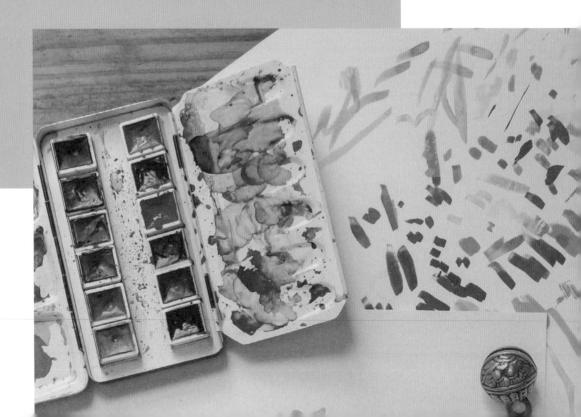

SELECTING MEDIA

At the moment I enjoy combining watercolor paper with markers, colored pencils, and crayons, to create layers of delightful texture.

Watercolor paper is not the obvious choice when using markers such as Copics because it absorbs lots of ink and your markers can get wasted earlier. The ink can also bleed into the paper, making it difficult to control and create sharp lines. Although it can be challenging to use this combination, I love the textures and shades of color that can be produced, so I continue to develop my technique.

My tastes often change as I adapt new techniques and experiment with new media. Before moving into illustration, oil paints were definitely my favorites – I'm sure I'll pick them up again someday soon!

"IF I'M PAINTING FOR MYSELF, JUST FOR FUN, I LIKE TO KEEP IT MESSY AND EXPLORE IN EVERY STEP, RISKING EVERY DECISION INTO A POTENTIAL DISASTER"

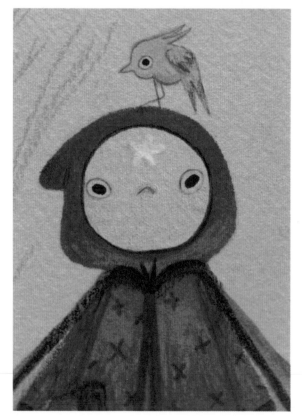

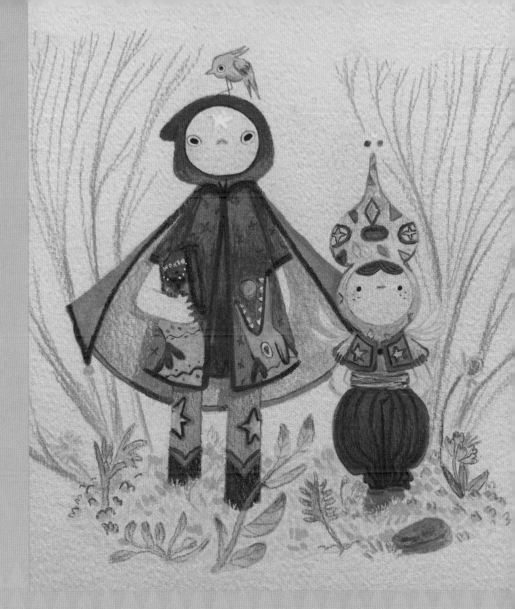

CRAFTING THIS PAINTING

This particular painting was created on heavier handmade watercolor paper with a higher GSM, using markers and colored pencils.

First, I used markers to layer the local colors, before coloring on top with colored pencils to add texture, and finishing tiny details, linework, and subtle gradients using sharpened colored pencils.

CHARACTER BUILDING

There are a lot of things to take into consideration when developing a character, especially as I like every character I create to display a little story behind them.

Many different aspects of a design enhance the character's personality – pose, expression and attitude, color, and above all, shape.

I begin with simple shapes and once I am happy with the overall shape language, I make more precise design decisions to refine my character.

Sometimes I start with a silhouette I like and then shape it into the character I want it to become. Or alternatively, I will already have an idea of what I want to achieve, and try to find that character with a bunch of little pencil sketches.

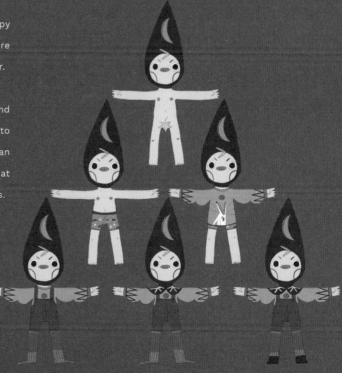

THE CHARACTERS OF *WONDER*

Meet the four characters I designed especially for *Wonder*

AiRi

- THE CURIOUS -

Airi is the youngest of Wonder's characters. She is pure love, innocence, and curiosity. She can make you see the unseen! Her hoodie is very special: it carries the primary colors and is able to create new colors anytime it wants. Airi can see all possible colors of the universe, even the ones you're not able to imagine.

LAURENT

- THE WISE -

Do you believe in monsters? How about fairies and trolls? Laurent does, and does not. He is balance, silence, and precision. If you're ever lost or you think you're found, Laurent can prove you wrong. And right. He is the exit from a path without an end, the silence of all sounds, and the reason for the order of all things that you can't find an answer for yet. Choose Laurent as your friend and you'll observe all opinions and matters with every possible point of view.

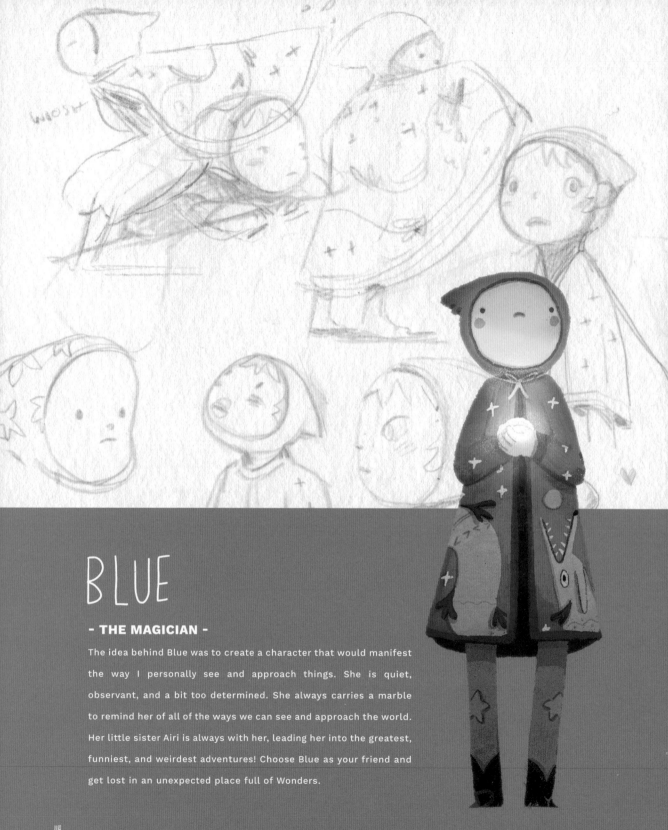

BLUE

- THE MAGICIAN -

The idea behind Blue was to create a character that would manifest the way I personally see and approach things. She is quiet, observant, and a bit too determined. She always carries a marble to remind her of all of the ways we can see and approach the world. Her little sister Airi is always with her, leading her into the greatest, funniest, and weirdest adventures! Choose Blue as your friend and get lost in an unexpected place full of Wonders.

JUNGLE

- THE DOG -

It's not an adventure without Jungle. Jungle is a happy dog who loves the forest and the beach. She likes water on her paws but never to swim, although she would jump into the deepest ocean to rescue any of her loved ones. She loves to carry a bugle with her. Pick Jungle as your partner and find the most amazing Treasures anywhere you go.

DESIGNING FOR PICTURE BOOKS

Designing picture books is similar to any big project in terms of creative process and development, except that when I've worked on an animation project or videogame as a visual development artist, it has been someone else's project, not mine.

Most of the time when I've designed something, it has been passed on to another department; such as 3D modeling or animating.

The project is a team effort and combining our skills to create something beautiful that I would not have been able to create on my own is an absolutely amazing feeling.

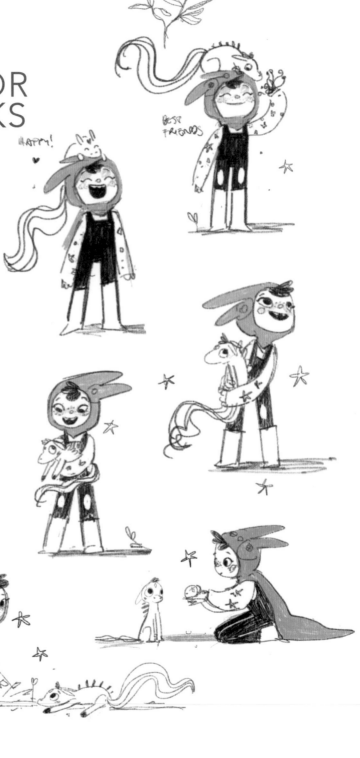

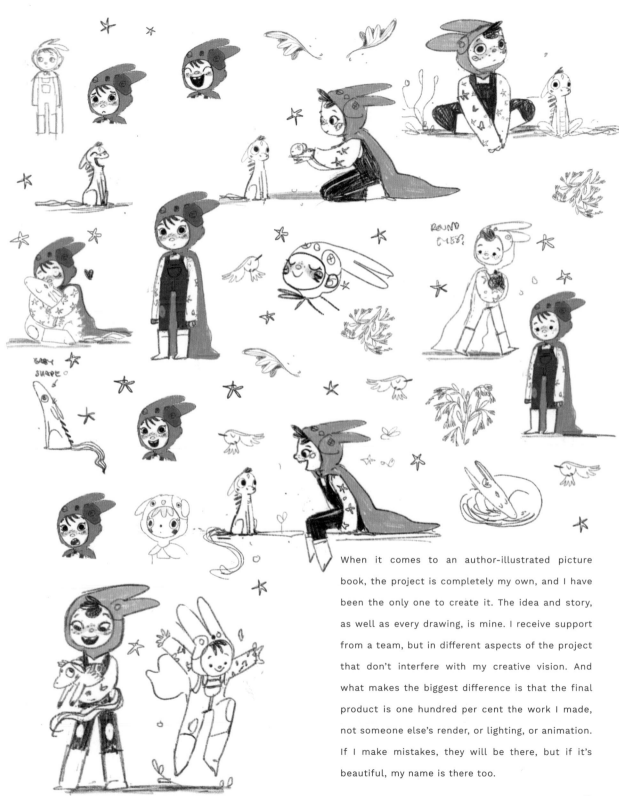

When it comes to an author-illustrated picture book, the project is completely my own, and I have been the only one to create it. The idea and story, as well as every drawing, is mine. I receive support from a team, but in different aspects of the project that don't interfere with my creative vision. And what makes the biggest difference is that the final product is one hundred per cent the work I made, not someone else's render, or lighting, or animation. If I make mistakes, they will be there, but if it's beautiful, my name is there too.

"WITH EVERY SPREAD I LEARN MORE ABOUT STYLIZING, SHAPES, NARRATIVE, AND SO MUCH MORE!"

The first picture book that I wrote and illustrated is called *Once Upon a Unicorn Horn*, published by Frances Lincoln. It was an amazing project to work on and seeing it translated into so many different languages is such an incredible feeling. I learned so much during the process of it and I'm trying to apply as much as I can to my upcoming picture book.

This second book will be about a dragon and it's super exciting to finally start working on it. With every spread I learn more about stylizing, shapes, narrative, and so much more!

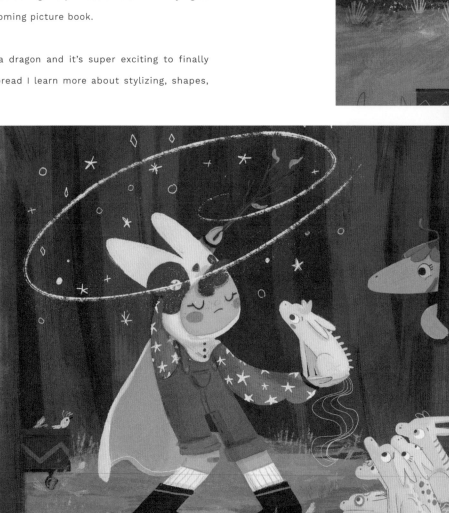

Designs taken from *Once Upon a Unicorn Horn*, published by Frances Lincoln. →

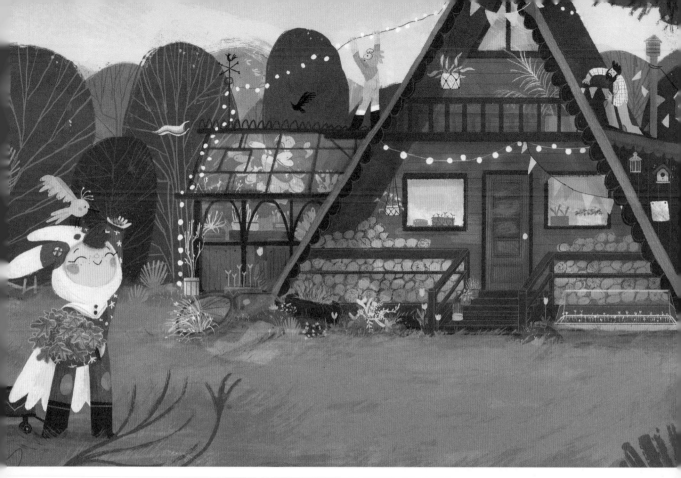

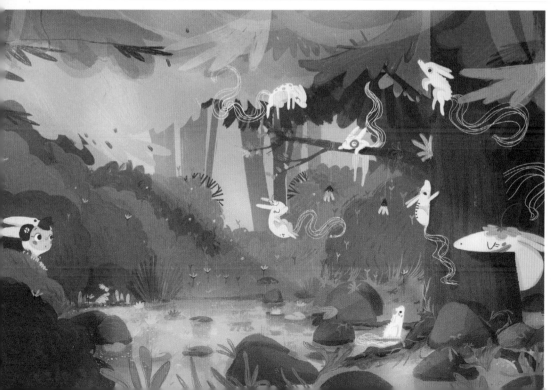

CHILDHOOD WEEK

The idea behind Childhood Week originated from the first book I ever illustrated. It was not the easiest topic to illustrate, as it was about a horrible kid. I wondered what I could do to enjoy the process of illustrating it and how I could make every single illustration enjoyable for the viewer.

The movie *Matilda*, based on the story by Roald Dahl came to mind, and I tried to recreate that same 80s/90s feeling in my illustrations. As well as making the process a really enjoyable experience for me, the addition of vivid color as well as 90s clothes and props gave the illustrations more interest and depth.

After creating a few more illustrations with 80s and 90s vibes and sharing them on social media, I realized a lot of people had stories to tell about their childhood. I then pondered the idea: what if we could see every artist or person we admire when they were kids at the same time? Would we have been friends? Did a certain toy or moment make an imprint on us simultaneously? It was impossible to know. But what if we shared a topic and we all talked about it from our point of view for a bit?

And that was the start of the Childhood Week social media challenge.

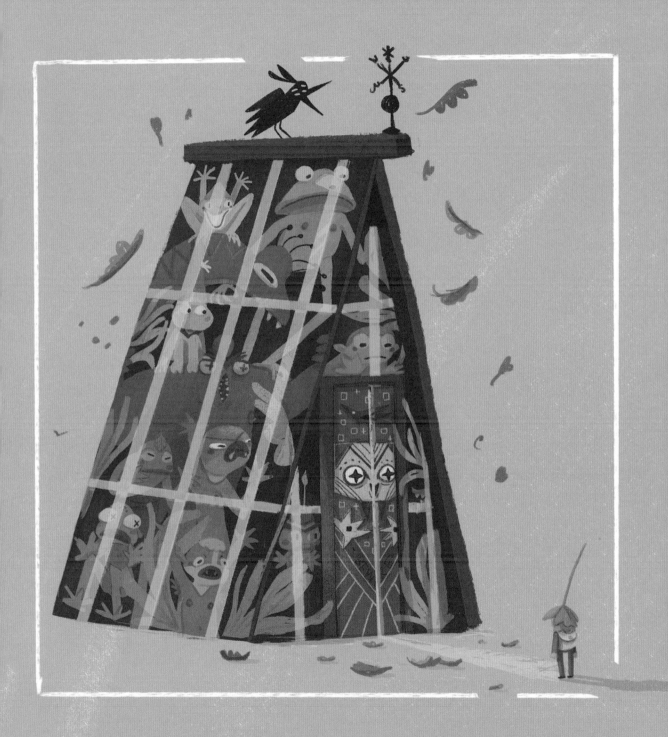

The following pages are filled with a selection of my favorite personal designs from previous Childhood Week events.

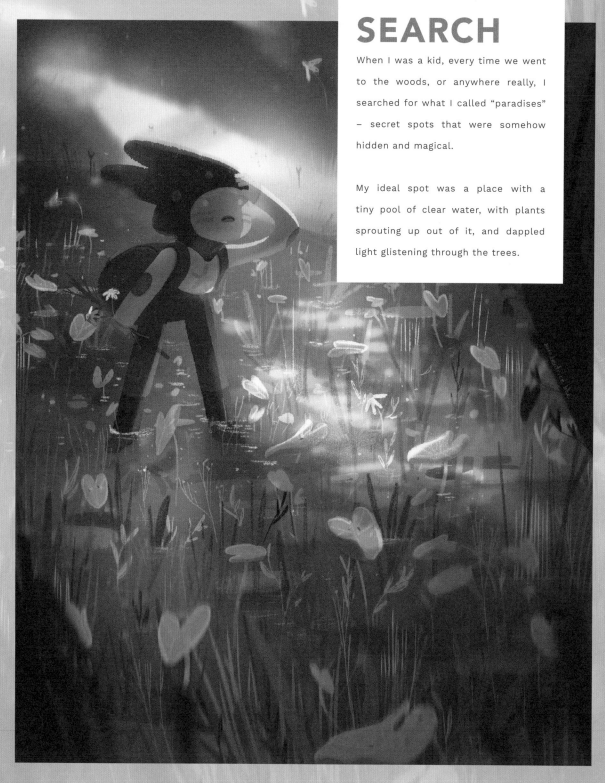

SEARCH

When I was a kid, every time we went to the woods, or anywhere really, I searched for what I called "paradises" – secret spots that were somehow hidden and magical.

My ideal spot was a place with a tiny pool of clear water, with plants sprouting up out of it, and dappled light glistening through the trees.

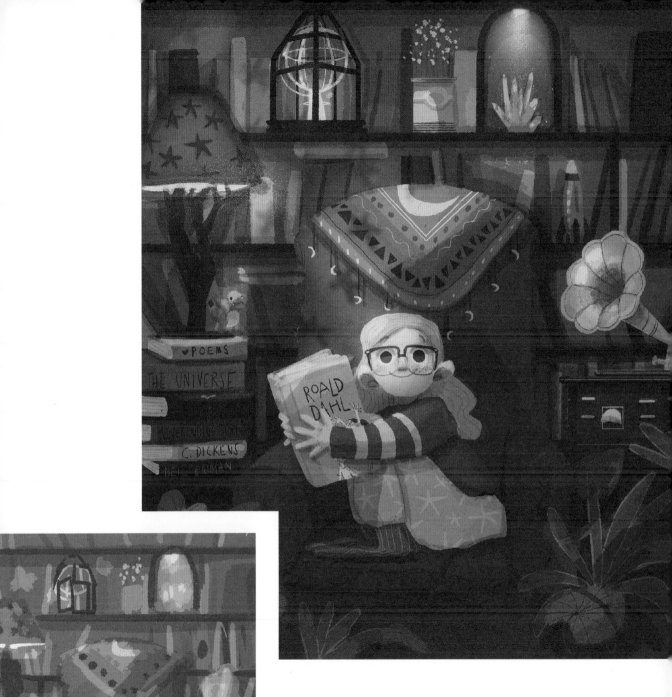

STORM

Storm days were the perfect days. They had everything – pajamas, the sound of rain and cracking thunder, warm beverages and soft lights. They were (and still are) the most wonderful days to stay in and read the perfect book.

RAIN

RAIN

Ever since I can remember, whenever it rains I feel an incredible urgency to go outside to wander and think. I love the smells, the fresh water falling, and the delicate sounds; almost silent but not quite. When I was a child I used to think that if I wished very hard I could turn into rain. Or into a puddle at least. Oh well.

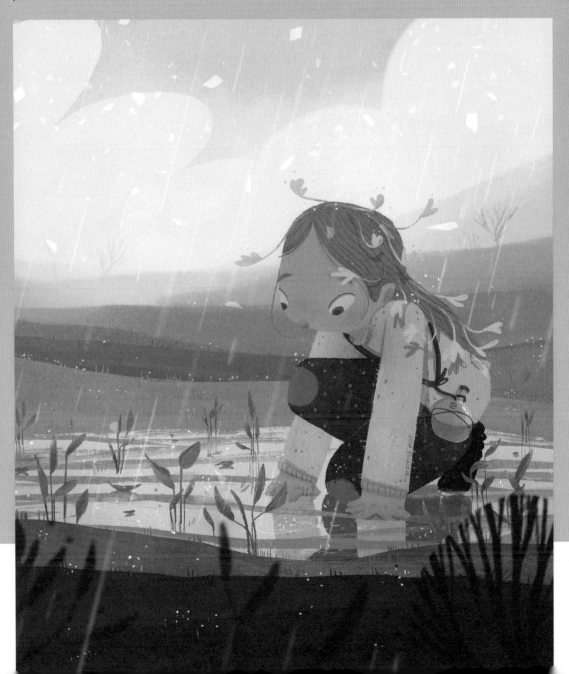

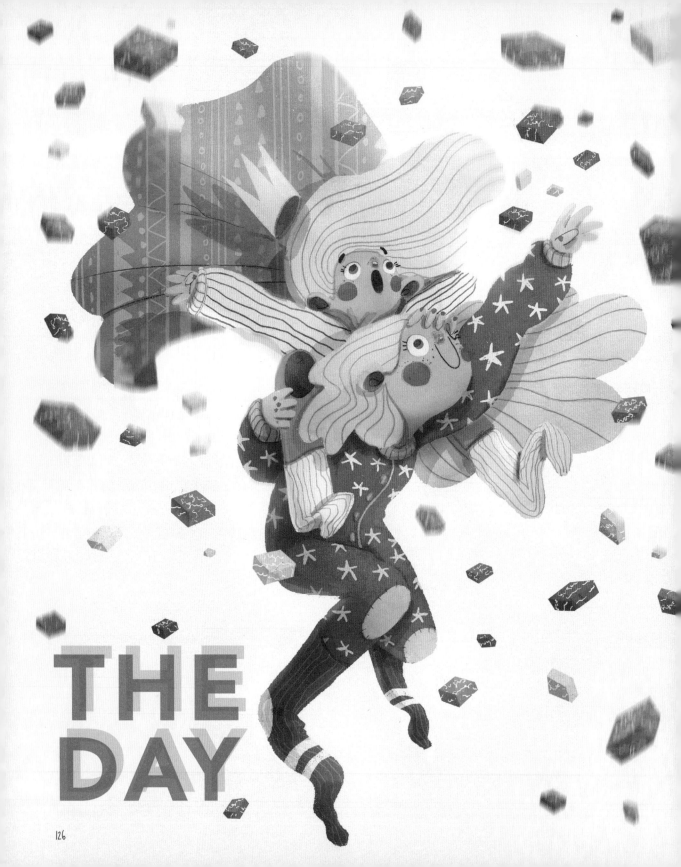

THE
DAY

On the 5th of January every year, the three wise men come over to Spain. We leave lettuce for their camels and wine and cookies for the kings. The next day our house is full of surprises and presents, but the most important parts for my sister and I were the colorful candy and spending time together as a family.

This tradition still happens every year. The three kings make a path of candy from the bedrooms to the Christmas tree, and we follow the path with our hearts bumping hard with joy and our pockets full of little tiny squares of color.

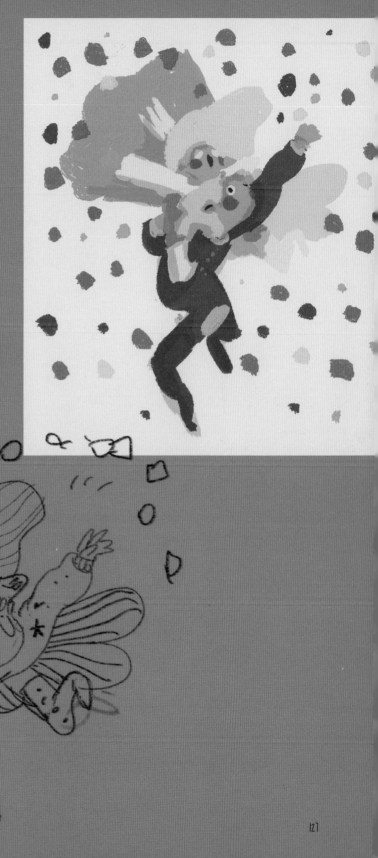

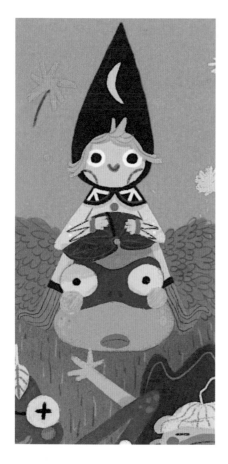

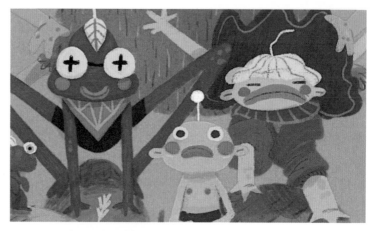

For me, magic has always been hidden in every pond inside a forest, where the lily pads rest and the water is almost crystalline. As a child I would dream of swimming in them and finding the most amazing creatures. I would sit and stare for ages whenever I found one. They were and are my little paradises.

I also believe that is where creatures such as Sīv and Dani's little character from his *Labyrinth* (the small blue one) were born (so I dressed myself as Sīv).

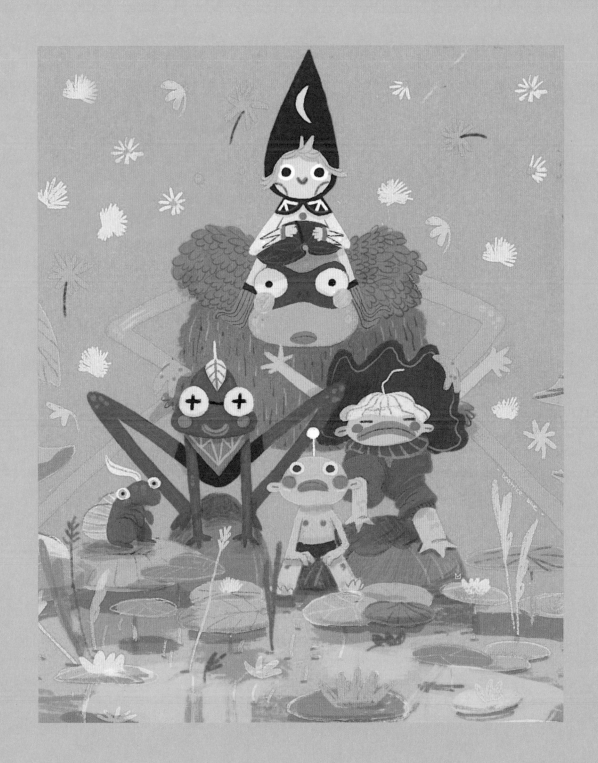

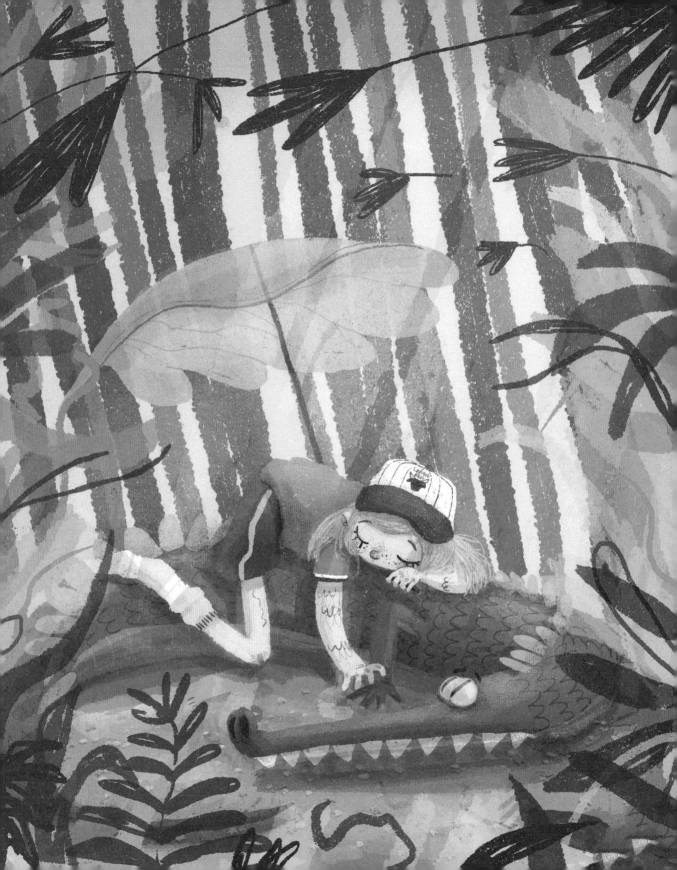

EXPLORE

When I was little, whenever my parents would take siestas in the afternoon, I would sneak out of the house and go searching for adventures. During my explorations I made many unbelievable friends and saw many secret and incredible Wonders.

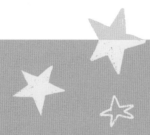

HIDEOUT PLACE

There were some bushes down by my house where I loved hiding and making potions. It was my special secret place. I would mostly spend time in them during the springtime, when they were packed with fresh new leaves that would cover me completely. Time seemed to stop every time I went inside my magic leafy cave. And of course, my treasured panda bear pin always came with me.

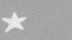

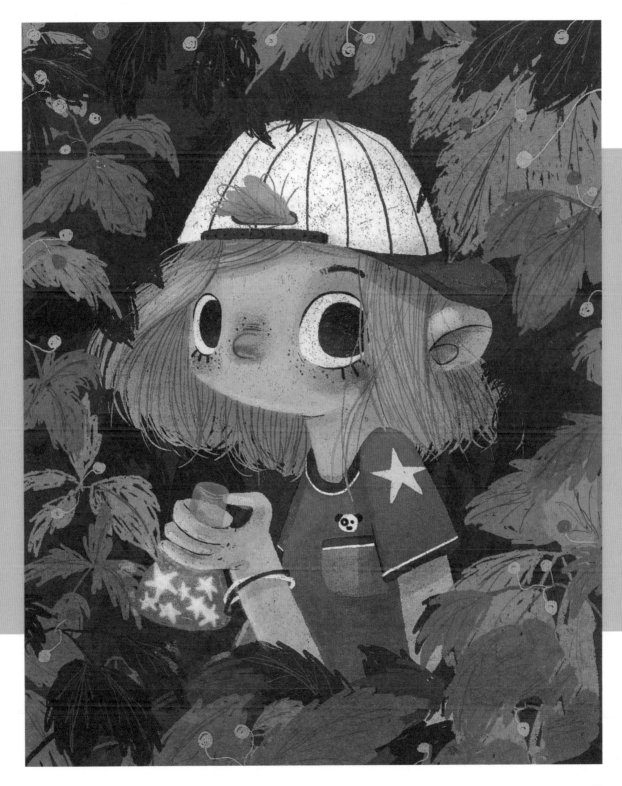

THE
FOLD-OUT

I wanted to create a fold-out design for *Wonder* that would capture the intriguing and mysterious feeling that occurs when we are just about to create something.

I see the mind as a glasshouse full of Treasures – ideas we collect and gather with time. To tell a story, I pick some of those ideas, and through my art, I try to communicate to the viewer what they mean to me.

So to begin my fold-out design, I decided to use the metaphor of this book, a glasshouse, full of Treasures already collected. And to convey the brief period of time when observation is almost over and I'm about to start to draw, tell a story, or just create something.

Sometimes when I can clearly imagine all of the ideas I want to show, and I just need to put them onto paper, there's a very silent moment. In that still moment, it all makes sense, and everything behind me and ahead of me is just enhancing this key idea. It feels like I have already created what I'm about to draw or make.

Although it might sound poetic, it can be a very tricky moment. If I don't execute what is in my head correctly, I will hate the idea and it will all crumble into frustration.

My solution to this is trying to be organized with how I develop the illustration or project and to take my time and think about each step. Taking a slower pace is something I find very hard sometimes.

In this case, I started with a sketch to visualize my main idea and the concept. As this sketch is quite messy and the angle of the view is quite strange, I had to give the glasshouse some structure so that the perspective would make sense.

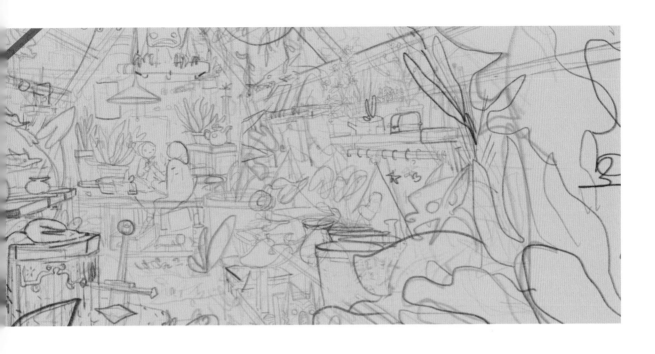

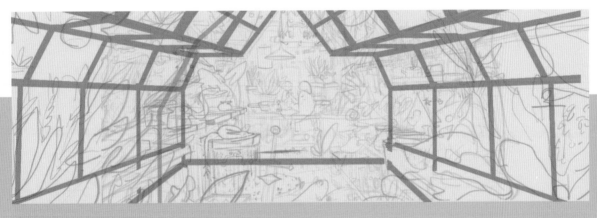

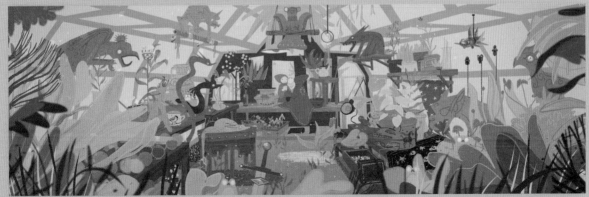

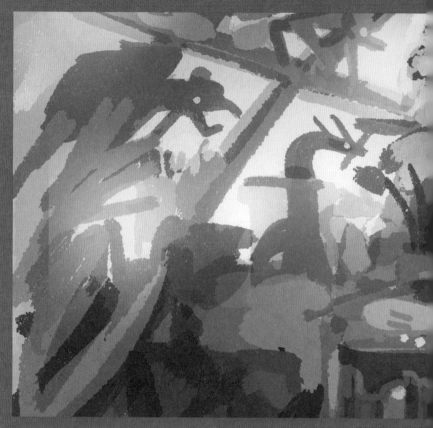

To see if my initial idea would work, I felt like I needed to see it in color. A quick color test helped with a lot of my design decisions. For example, I realized that leaving white space for the windows would allow the light to shine into the room a little, and not adding too many things on the floor would let the drawing breathe a bit.

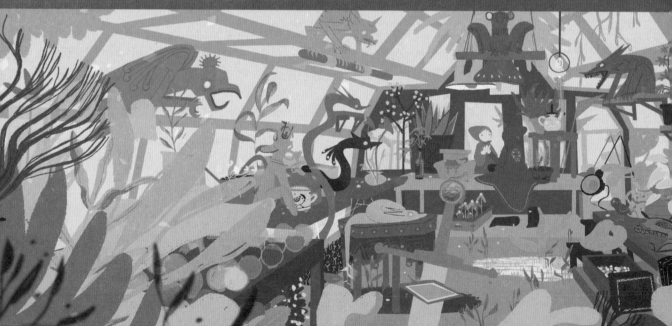

"I REALIZED THAT LEAVING WHITE SPACE FOR THE WINDOWS WOULD ALLOW THE LIGHT TO SHINE INTO THE ROOM A LITTLE"

Since we wanted the illustration to be a large panoramic pull out, to fit inside this book, I opened up the frame of the design to display more of the sides too; creating a little bit more of a wide-angle perspective.

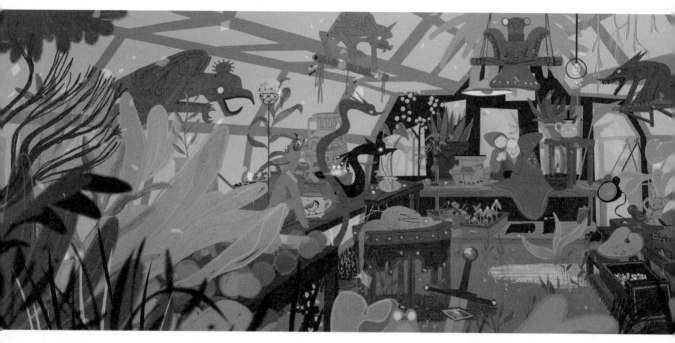

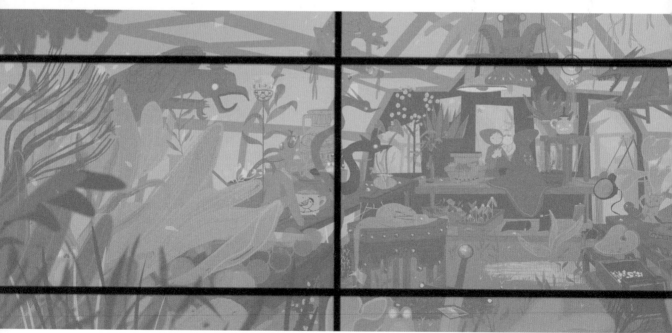

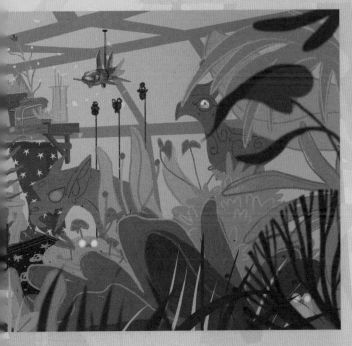

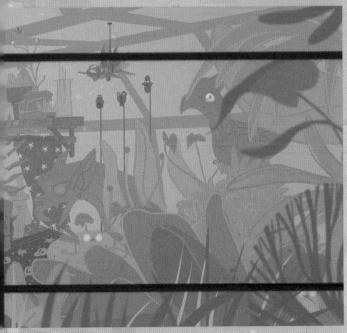

I wanted to keep the main focus on the central point, where the narrative is taking place. This way the surrounding scenery can support the story and give it greater context. Maintaining a strong composition is key in order to tell the story right.

Setting the image to black and white from time to time helps me see if my values are correct and check that every object is readable and distinct from the rest.

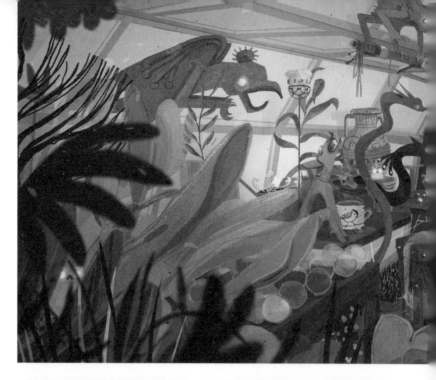

"I TRIED TO ADD A STRANGE LIGHTING THAT SEEMS TO HAVE NO REAL SOURCE..."

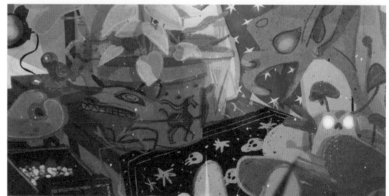

And finally, the part of the design process that I find the most fun – lighting! To enhance my main idea and keep it a bit mysterious and on the edge of comfort and discomfort, I tried to add a strange lighting that seems to have no real source...

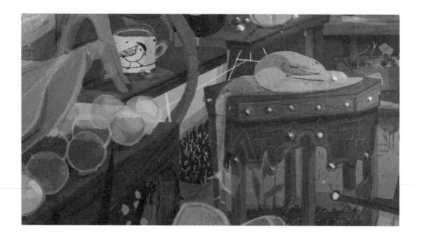

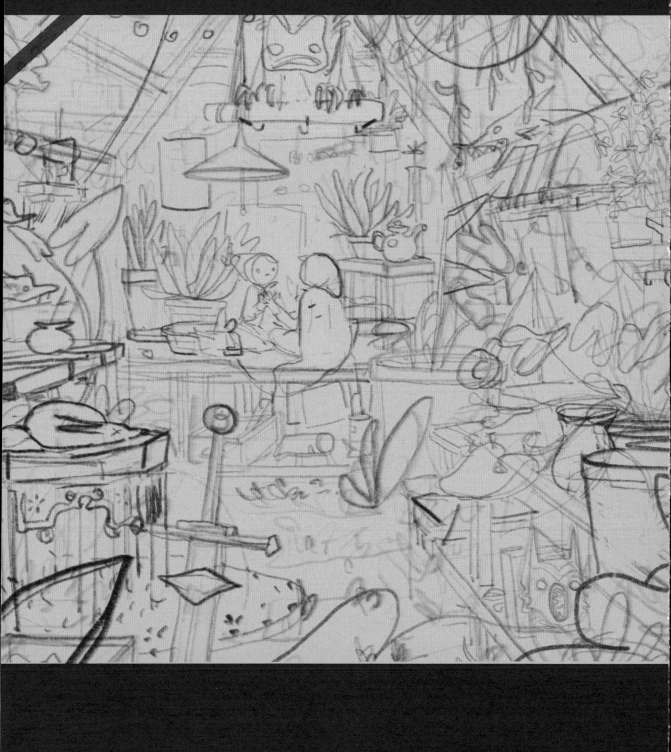

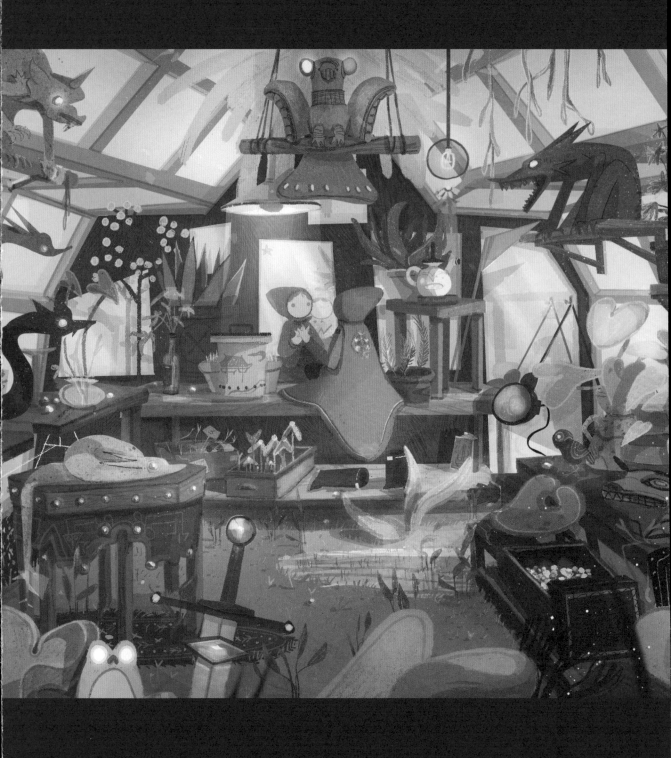

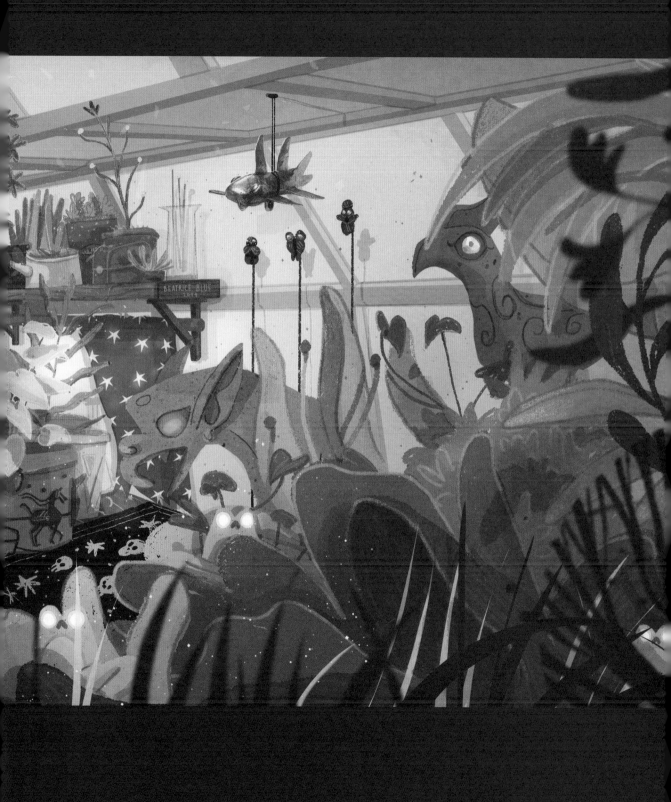

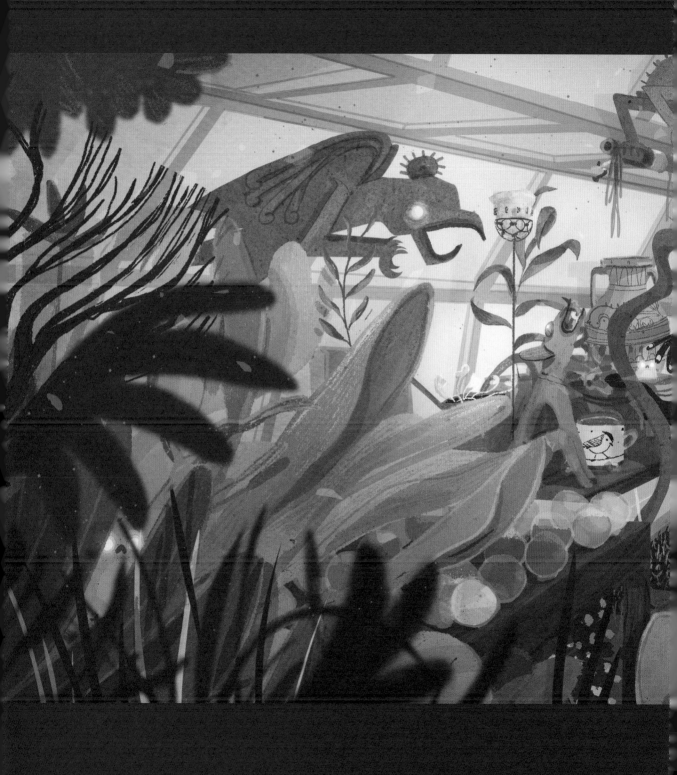

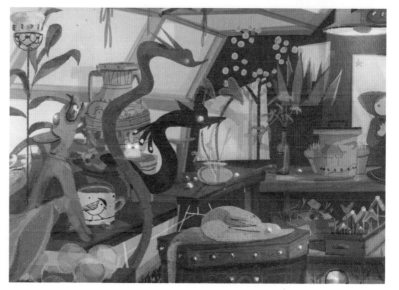

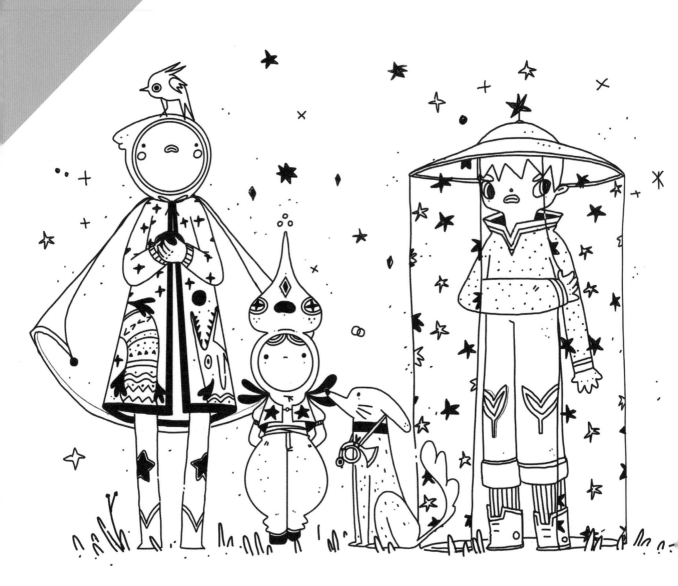

WONDER

Stories can mean as little to us as an unseen shadow or as much as the sun after a cloudy month. They are like meals – tasty while you're enjoying them, but just one meal of thousands you will have in your life.

However, when a story is made up of Treasures it leaves a trace. Even if you don't remember the story years later, there is always something that evokes a feeling in you when you think of it randomly. Just like that smell that can give you goosebumps or a sound that makes you cry. I call that: Wonder.

My glasshouse is full of Treasures. Some of them are now stories. And a few of them have become Wonders. But they all aid the never-ending search for those special Wonders. And most importantly, they all make me, *me*.

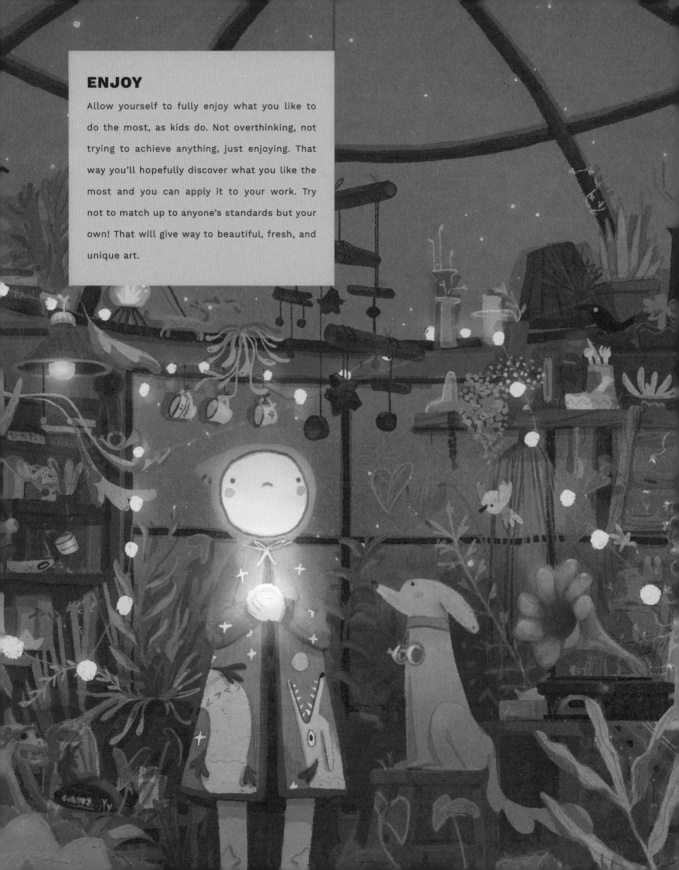

ENJOY

Allow yourself to fully enjoy what you like to do the most, as kids do. Not overthinking, not trying to achieve anything, just enjoying. That way you'll hopefully discover what you like the most and you can apply it to your work. Try not to match up to anyone's standards but your own! That will give way to beautiful, fresh, and unique art.

MAKING THE COVER ART

To develop a cover idea that matched the subject and overarching metaphor of the book, I created a few quick sketches on the iPad.

I kept these initial sketches as simple as possible, because I was conscious that I'd only require one.

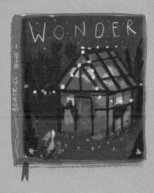
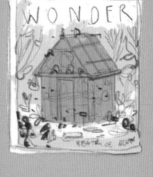
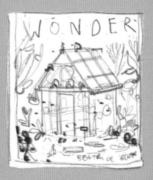

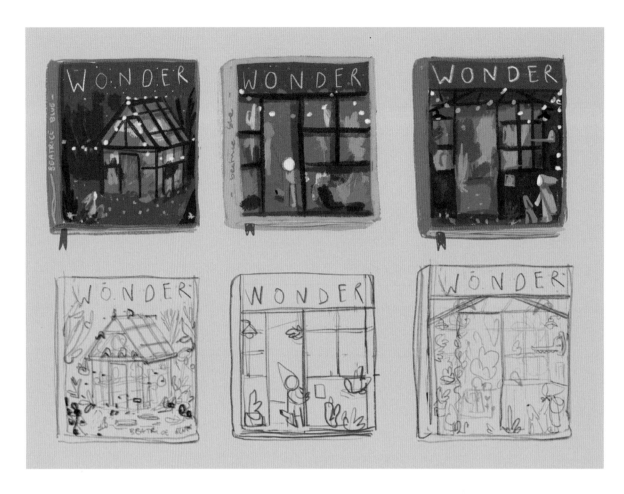

My aim was to create drawings that visualized the book as a whole, and best explained the concept behind it, so perspective was important. I decided to give the reader a view of the inside of the glasshouse and depict the characters facing forward to make it feel a bit more serious, but still magical and intriguing.

I liked the idea of featuring the outside of a glasshouse, but decided to use it for the back cover instead.

I drew this design digitally with the iPad, using a loose line. While drawing I was remembering my grandparents' house and a story I wrote about a glasshouse for Dani a long time ago.

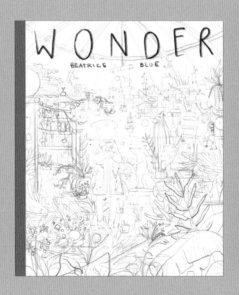

I tried both daytime and nighttime lighting with my design to see what would fit best with what I wanted to tell. I chose option C (below), and used the design of option A for the back cover of the book.

When working on these color tests digitally, I set the zoom far out and used a big brush with almost no texture, so that I didn't get engrossed in the details. My main focus at this point was the mood and lighting. I also tried to work as quickly as possible for the same purpose.

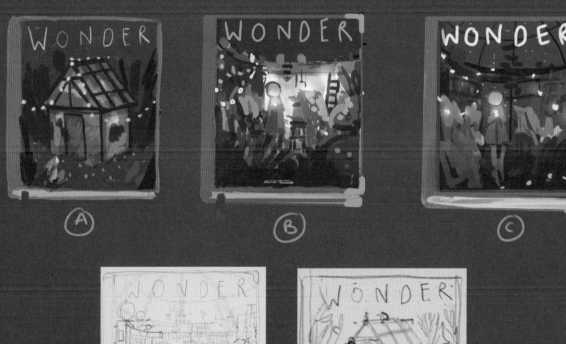

↓ Here are just a few of my favorite details from the cover.

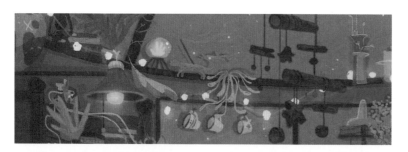

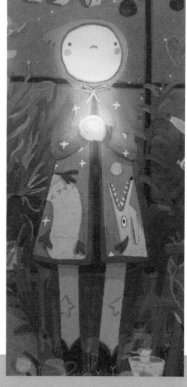

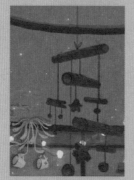

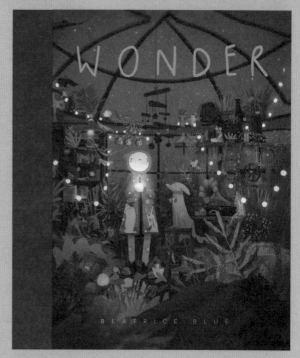

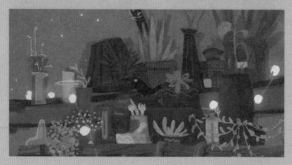

CHASING THE WONDER

My work changes as I change. The more I learn about what I want to show and say, and about who I really am, the more consideration and care I give to each aspect of a design. I now think in terms of "quality over quantity" – running parallel with my own set of personal values. I used to give more importance to people liking what I created and forgot about what I wanted. The transition in my mindset took place when I decided that I wanted and needed to share what I had to say, and not what others wanted to hear or see.

I hope the viewer takes joy, an eagerness to create, and Wonder from my art.

I have found what and how I like to draw today, but I have no idea about how and who I will want to be tomorrow. I love respecting that, because it enhances the beauty of getting old and never growing up. If I had to name an artwork that I'm proud of, it would probably be today's, or tomorrow's.

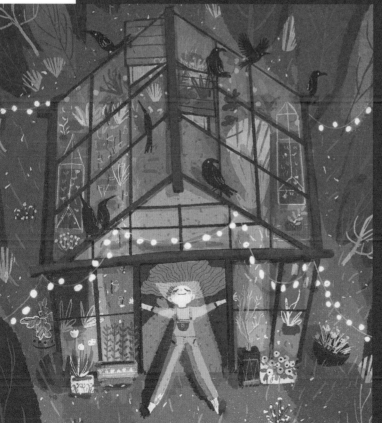

However, I might be proud of a drawing one day, but find that I might not be able to say the same for the next drawing. I usually like a piece of artwork the moment I can understand how much I have learned or how much of myself I put into it. But as soon as I learn something new, I forget about the piece that I was so proud of and focus on my latest knowledge instead.

The more I grow as a person and as an artist, the more I want to concentrate on developing my own personal projects. Working for others is great, but I have so many stories I want to tell too.

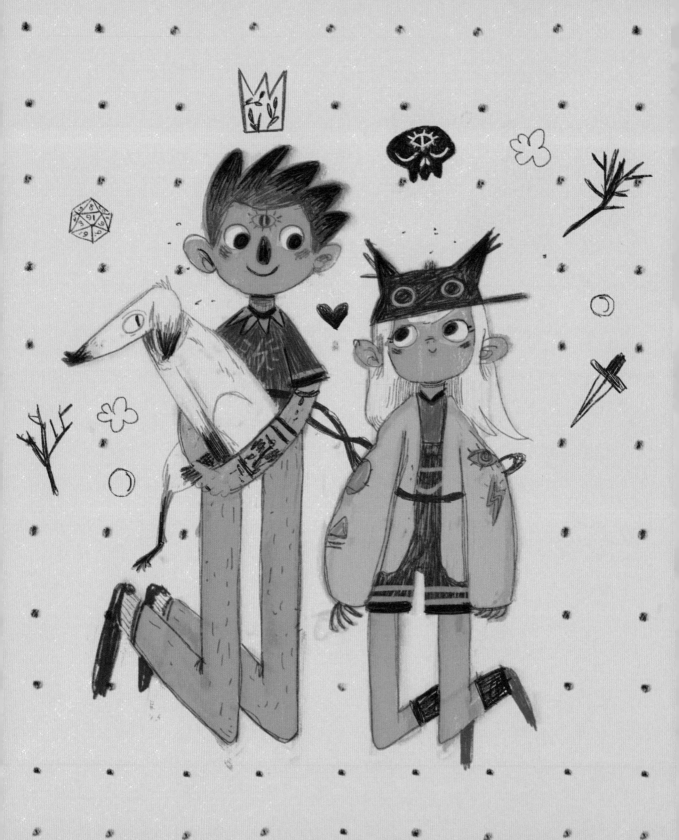

THANK YOU!

I want to first thank Dani for his unconditional love and all the adventures we live together every day. I don't think *Wonder* or any other book, story, or illustration would be the same without you.

Thank you Sophie, my lovely editor, for all the love and dedication you've put into this book. Thanks to *Wonder*'s great designer Imi for all her effort, patience, and good work. And thanks to the whole 3dtotal team for this amazing experience.

And thank you to every single one of you who has bought this book. That is one of the main reasons *Wonder* is in your hands right now. I am so grateful for your constant support and encouragement.

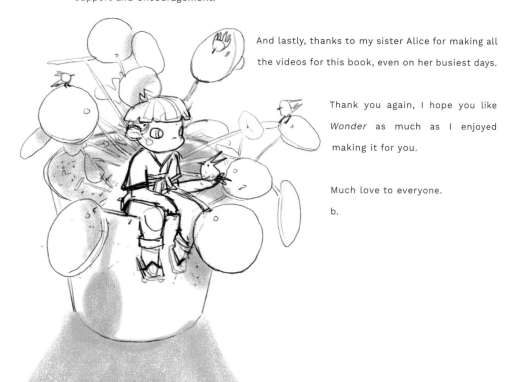

And lastly, thanks to my sister Alice for making all the videos for this book, even on her busiest days.

Thank you again, I hope you like *Wonder* as much as I enjoyed making it for you.

Much love to everyone.

b.

ABOUT 3DTOTAL

3dtotal Publishing is an independent publisher specializing in inspirational and educational resources for artists. Our titles proudly feature the stunning artwork of top industry professionals, who share their experience in step-by-step tutorials and guides, offering you creative insight, expert advice, and essential motivation.

Initially focused on the world of digital art, with comprehensive volumes covering Adobe Photoshop, Pixologic ZBrush, Autodesk Maya, and Autodesk 3ds Max, our scope has since expanded to offer the same level of high-quality training to traditional artists. Including the popular Beginner's Guide series, artist showcase books, and Sketching from the Imagination series, the 3dtotal library is now comprised of over fifty titles, a number of which have been translated into different languages around the world.

3dtotal Publishing is an offspring of 3dtotal.com, a leading website for digital artists founded by Tom Greenway in 1999.